CLINTON

CLINTON

A BRIEF HISTORY

NANCY SNELL GRIFFITH

Charleston · London

THE
History
PRESS

Published by The History Press
Charleston, SC 29403
www.historypress.net

Cover images: Front: Broad Street, looking south, circa 1913. Postcard published by the Clinton Pharmacy. *Courtesy of the Clinton Museum*; Clinton Mill baseball team, undated. *Courtesy of the Clinton Museum*. Back: Broad Street, looking north; *Wide Awake Clinton* (brochure), 1922. *Courtesy of Presbyterian College*; Junior class, Clinton High School, 1926–27. The 1927 *Clintonian*.

First published 2010

Manufactured in the United States

ISBN 978.1.59629.647.3

Library of Congress Cataloging-in-Publication Data

Griffith, Nancy Snell.
Clinton : a brief history / Nancy Griffith.
p. cm.
Includes bibliographical references and index.
ISBN 978-1-59629-647-3
1. Clinton (S.C.)--History. 2. Clinton (S.C.)--Social conditions. 3. Clinton (S.C.)--
Economic conditions. I. Title.
F279.C66G75 2010
975.7'31--dc22
2010010168

CONTENTS

Preface 7

CHAPTER 1. BEGINNINGS
Early Laurens County 9
The Organization of Clinton 13
Life in Clinton before the Civil War 18
Civil War Years 21
Reconstruction 23

CHAPTER 2. PROSPERITY AND GROWTH
An Improving Economy 39
Industry Comes to Clinton 52
A New Century 55

CHAPTER 3. A WORLD WAR AND A DECLINING ECONOMY
World War I and Its Aftermath 79
The Great Depression 93
The Prewar Era 99
World War II 105
Postwar Years 107

CONTENTS

CHAPTER 4. INTO ITS SECOND CENTURY: A BRIEF RECAP
OF RECENT HISTORY

The 1950s and 1960s 117
The 1970s 125
The Last Thirty Years 129

CHAPTER 5. BRIEF INSTITUTIONAL HISTORIES

Thornwell Orphanage 135
Presbyterian College 136
Whitten Center 138

Appendix: List of Mayors 141
Bibliography 143
Index 147
About the Author 159

PREFACE

It is important to say at the start that this is not *the* history of Clinton, but rather *a* history of Clinton. Every person who has looked at the historical record probably draws different things from it. This material is what I have chosen to include. I have undoubtedly omitted things that some people would consider important or emphasized things that another writer would not have. I have purposely included more information for the earlier years and not as much for the period following Clinton's centennial in 1952.

For events that occurred prior to 1917, I have relied heavily on Dr. Jacobs's diary and the local columns he wrote for *Our Monthly*. I have skimmed innumerable issues of the *Clinton Chronicle* for information and also consulted back files of the *Laurens Advertiser*. The various commemorative issues of the *Chronicle* were especially helpful.

I have also relied on previously published histories, checking their authenticity against primary sources where possible. It is always surprising when sources disagree wildly on the facts. When there was disagreement, I always took the facts from a contemporary source rather than a later account. In many cases, I have tried to provide state or national context for local events. I hope I have provided enough information without being too detailed.

Previous histories have contained limited information on Clinton's African American population. I have tried to include as much as possible about the churches, schools and individuals that played a significant part in the black community.

There may be some who question the inclusion of the less pleasant aspects of Clinton's history, like the Dendy lynching or the labor unrest of the 1930s. I feel that if an event is front-page news in local newspapers—as well as in national publications like the *New York Times*, the *Atlanta Journal* and the *Nation*—it is worthy of inclusion in any thorough history.

Despite careful research, there are undoubtedly errors in fact present, for which I apologize. I also apologize for the variant spellings of some of the names, and the occasional use of different names for the same person. I listed them as they were listed in the original sources. This may be particularly apparent in the index. The index itself is far from perfect, in part because of the complexity of the indexing program. However, I thought it better to include an imperfect index than none at all.

Many people have provided help with this book. The staff at the Clinton Museum provided a number of pictures, as did the Presbyterian College Archives staff. Many of those from PC are in the Vance Collection, donated to the college by Mrs. Virginia Vance. Sarah Leckie was my intrepid scanner for the majority of these photos. Lawrence Young provided numerous pictures as well as access to his many historical scrapbooks. He also proofread one version of the manuscript. Dianne Wyatt also shared her scrapbooks, which covered Clinton's history since 1974. Donny Wilder has read through the whole manuscript with a very keen eye, and John Griffith has been through it at least twice and made helpful suggestions each time. Many thanks to them both. Thanks to Barbara Barksdale for her tireless detective work. And also thanks to Wanda Isaac for information on the black community in Clinton, particularly information on the Friendship School. Young Dendy graciously provided materials on his father's lynching, and Thomas Vance donated materials to PC's archives about the unrest during the summer of 1970. Others who contributed information on the black community include Tim Stoddard, Lumus Byrd, Shirley Jenkins and Ann Childs Floyd.

Chapter 1

BEGINNINGS

EARLY LAURENS COUNTY

In 1663, Charles II of England granted the area known as South Carolina to eight Lord Proprietors. Prior to European settlement, the region was occupied by a number of Native American cultures, including the Mound Builders of the Mississippian era, the Catawbas and the Cherokees. The upstate area was attractive to settlers because of its numerous rivers, which provided transportation and rich bottomland for farming. The first settlers also found an abundance of wildlife, including buffalo, wild turkey, deer, bear and beaver.

At the time of early European settlement, Laurens County was occasionally home to the Cherokee Indians, who came into the northwestern part of South Carolina in the sixteenth century. While their permanent settlements were located along the Keowee and Savannah rivers in the northern and western part of the state, they used areas in Laurens County for hunting grounds and temporary camps. All that remains of their presence today are artifacts like broken pots, weapons and implements, as well as the names of such local features as the Enoree and Saluda rivers.

By 1684, the Cherokees had signed a treaty with South Carolina and had begun to trade in deerskins and Indian slaves with white traders. This new dependence on trade goods led the Cherokees to ally themselves with the British in their wars with the French and Spanish. The Cherokees, who began to arm themselves with firearms by the late seventeenth century,

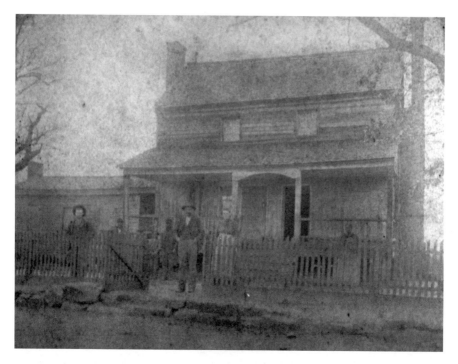

The Adair Homestead. *Courtesy of Lawrence Young.*

were also in constant conflict with their neighbors, the Catawbas, Creeks, Choctaws and Chickasaws.

Europeans did not generally consider the Cherokees a hostile tribe; rather they were viewed as an obstacle to settlement. In the middle of the eighteenth century, settlers of Scottish, Irish, English and German descent were drawn to some parts of the South Carolina piedmont by Governor Robert Johnson's township program. This program gave tax incentives and free land to settlers willing to occupy land northwest of the Lowcountry. The township program did not extend into Laurens County, however, and settlement there did not start in earnest until 1755, when the Cherokees ceded all land south of what is now the Greenville–Laurens County line.

It was about this time that John Duncan arrived from Pennsylvania to settle in the northeastern part of present-day Laurens County, on the creek that now bears his name. Other early settlers included James Adair, Joseph Adair, Abraham Holland, Thomas Westmoreland, Agnes Young and Robert Long. In 1760, however, war erupted with the Cherokees, which temporarily

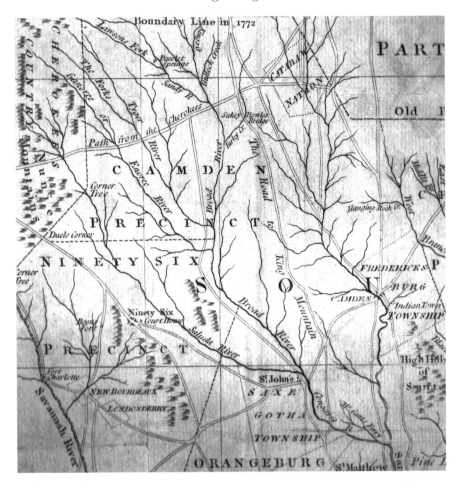

Upstate South Carolina, detail of *A New and Accurate Map of the Province of South Carolina in North America*, 1779. *Courtesy of Presbyterian College.*

discouraged settlement. Attacks at Long Canes, Fort Prince George and Fort 96 caused South Carolina authorities to send Colonel Grant to quell the uprising. A treaty signed by Lieutenant Governor Bull in 1761 finally settled the boundary dispute, allowing widespread settlement in what had been the Cherokees' lower hunting grounds.

Settlers began to move into the Upcountry from Pennsylvania and Virginia, as well as from neighboring regions. In the ten years between 1760 and 1770, the percentage of South Carolina's population living in the backcountry increased from 50 percent to 75 percent. This period, however, was also

one of neglect by the provincial government. The lack of law enforcement resulted in the formation of groups known as Regulators, which attempted to impose order and eventually became a kind of extralegal government.

To put down the Regulators, South Carolina was organized into judicial districts in 1769. Present-day Laurens County became part of the Ninety Six District, with the village of Ninety Six serving as the county seat. During the Revolutionary War, the loyalties of the local residents were divided. Some sided with the British and some with the colonies. As a result, there were numerous local skirmishes, including important encounters at Lyndley's Fort (1776), Musgrove Mill (1780) and Hayes Station (1781). In 1785, the state was reorganized into counties, and Laurens County was founded. It was named in honor of Henry Laurens of South Carolina, who served as president of the Second Continental Congress. Laurensville (now Laurens), located about eight miles from Clinton, became the county seat.

By 1790, Laurens County boasted 1,395 heads of families, most of English, Scottish or Irish descent. By 1800, the county had a population of 12,800,

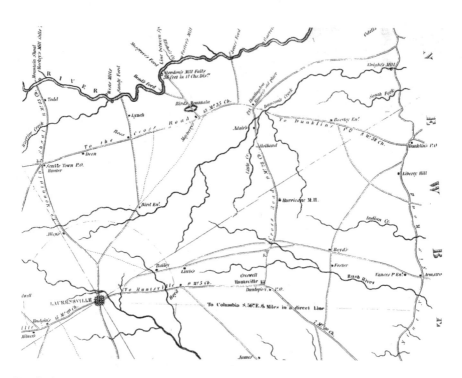

Detail of an 1820 map of Laurens County by Henry Gray, improved for *Mills' Atlas*, 1825. *Courtesy of Presbyterian College.*

including almost 2,000 slaves. Most early residents of Laurens County lived on farms and plantations. The local soil was well suited to growing cotton for market and corn and wheat mostly for domestic consumption. With the opening of British textile markets and the invention of the cotton gin in 1793, cotton became a major crop. Local farmers began to buy more land and more slaves to work it. In the early decades of the nineteenth century, the slave population in the county increased by 48 percent, while the white population grew by only 6 percent. After 1830, as the land began to wear out, the white population decreased further as farmers moved south and west. By 1850, the slave population in Laurens County had actually surpassed the white population.

THE ORGANIZATION OF CLINTON

Clinton was founded at an intersection called "Five Points," where the Greenville–Columbia and Spartanburg–Augusta roads intersected with

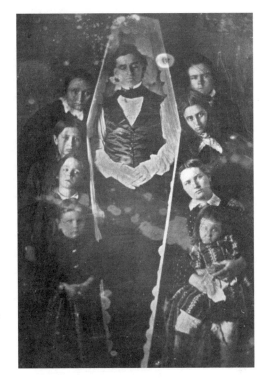

George Holland in his coffin, surrounded by his family, 1856. At the top left is Mr. Holland's widow, Louisa Copeland Holland. At the top right is his son, "Jack" Holland, who was killed near Richmond, Virginia, in 1862 while serving in the Confederate army. *Courtesy of Brent Holcomb.*

another road that came in from the northwest. This spot was one mile west of Holland's Store, which in 1809 was the only post office in the eastern part of Laurens County. Five Points featured a racetrack and was also a traditional gathering place for chicken fighting, drinking and gambling. Indeed, several accounts note that the first building in town was a barroom. The area was also a good hunting ground, since the surrounding swamps and ponds attracted migratory birds.

There were several early homes located near Five Points. George Henry Davidson, who was a furniture-maker, built his home on present-day Musgrove Street in 1829. In 1840, merchant Robert Phinney moved Judge John Hunter's house from the Bush River to what is now East Carolina Avenue. Mr. Phinney was a Presbyterian, and Reverend William Plumer Jacobs lived with him when he moved to Clinton in 1864. In 1848, R.N.S. Young built his home on South Broad Street on the southern edge of what is now Clinton. Another early home was that of Charles M. Ferguson, which was built on Musgrove Street about 1850.

There were also commercial buildings, including a railroad depot and a barroom. The surrounding land was so swampy that customers had to

Robert Phinney. From Thornwell Jacobs's *My People*.

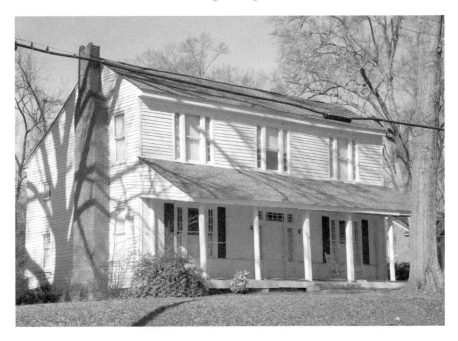

The R.N.S. Young House on South Broad Street as it appears today. *Courtesy of Presbyterian College.*

use gangplanks to access them. Gradually, additional homes and stores were built between the depot and Holland's Store. The prospect of the new Laurens Railroad, which was chartered in 1847 and completed in 1854, caused a land boom in Five Points. In 1852, widow Mary McKelvy (or McKelvey) and her son, James, entered into a legal battle over the land of Mary's deceased husband, John McKelvy. The Court of Equity appointed L.G. Williams, W.D. Watts, Jonathan W. Simpson, Thomas Little, Robert L. Owens and R.N.S. Young to partition the fifty-two acres of land into lots for a new town. While a few lots on the outskirts of the settlement contained between four and five acres apiece, most were about one acre, and those nearest the railroad averaged about one-fourth of an acre. There were only five streets laid out: Broadway (now Broad), Irby (now Carolina Avenue), Williams, Main and Pitts.

The new town was named "Clinton" in honor of Henry Clinton Young, Laurens attorney and state representative. The lots were sold in September 1852. According to the September 17 edition of the *Laurensville Herald*:

William Dendy Watts. *Courtesy of First Presbyterian Church.*

The original plat of Clinton, 1852. *Courtesy of Lawrence Young.*

The sale of lots ordered by the Commissioner of Equity took place in this embryo town on Wednesday last. We are informed that a large number of persons were present...the iron horse, that great promoter of modern energy and enterprise, bounded in their midst, and immediately awoke the most exciting and spirited rivalry. Lot after lot was offered for sale until...the whole number surveyed, were rapidly disposed of to some twenty different purchasers, at an average of over fifty dollars per acre. Under ordinary circumstances the land would scarcely have brought ten.

LIFE IN CLINTON BEFORE THE CIVIL WAR

Clinton developed quickly. In 1854, Methodists established the first church when they moved Zion Church from north of Clinton to a site at the corner of West Main and Laurens streets. By 1861, they were conducting a union Sunday school. Reverend Zelotes Holmes of Laurens, who was supplying Duncan's Creek Presbyterian Church, began holding services in Clinton in 1853. By 1855, he had organized the Clinton Presbyterian Church, and the congregation had a frame building located on present-day East Carolina Avenue. There was also an African American congregation, meeting under the leadership of Davie Johnson. The group met in various homes and would later be organized into Mount Moriah Missionary Baptist Church.

By 1855, Clinton had telegraph service, provided by a line between Columbia and Greenville, and by 1856 visiting photographers like J.S. Leonard and John Leigh were coming to town. That same year, the state legislature approved a charter for Clinton. There were also a number of businesses in town, including a mill for grinding corn and sawing lumber. Large quantities of cotton were being shipped through Clinton, and there was a "dinner house" to serve railroad passengers.

There were no public schools at the time, so residents relied on a number of private academies to educate their children. The first organized academy was apparently started by Methodists in 1858 and was under the supervision of James M. Wright. Thomas Craig gave land for the two-story frame building on what is now Academy Street. Robert S. Owens, J.T. Craig, George P. Copeland, R.S. Phinney and E.T. Copeland gave money to support the school. Mr. Wright had an assistant, and there was also a music teacher. The session house on the grounds of the Presbyterian church also served as a

Above: The original building, Clinton Presbyterian Church, later renamed First Presbyterian Church. *Courtesy of Presbyterian College.*

Right: Reverend Zelotes Holmes. *Courtesy of First Presbyterian Church.*

male academy, under the direction of Reverend Theodore Hunter. When the Civil War began, all classes were suspended in Clinton except for those occasionally taught by Mrs. R.S. Dunlap.

In 1862, a young man who would change the face of Clinton arrived for his first visit. Two years before he would settle permanently in Clinton, William Plumer Jacobs visited the town to deliver a sermon at the Clinton Presbyterian Church. He described Clinton as

> *a most forlorn and hopeless hamlet. The business center consisted of twelve or fifteen lop-sided frame buildings. None of them were beautiful with paint, but all looked as if they were very, very old. The railway depot which, of course, was most prominent to travelers by steam or highway, was a 20x40 building, weather boarded with plank on end, the cracks strapped except where the strapping had come off, and the whole leaning two feet out of the perpendicular.*

Clinton during this time was definitely a country town. Every family had a large garden and kept chickens, turkeys, cows, pigs and horses. Dr. Jacobs noted that stoves were new to the backcountry, and the one piano was very out of tune. Sewing machines did not appear until after the Civil War. Only the doctor and the preacher owned books. Young people spent evenings in front of the fire, popping corn and playing singing games. People married at a very young age; most were wed by the age of eighteen.

Sundays were for church. Even when the number of churches began to increase, not every congregation was able to hold weekly services, and residents attended whichever church happened to be open that week. According to Dr. Jacobs, Sunday dress was casual:

> *Young women and married women would go to church in calico dresses. The young women wearing sailor hats and the married women often with sun-bonnets. The men seldom thought that there was any need to brush their jeans suits, or black their boots, and for a good old elder to stretch off his feet on the bench, lean his head against the wall, listen to the preacher, if he liked him, and go to sleep if he didn't was a sin of common occurrence.*

Civil War Years

The Civil War put an end to progress in the fledgling town. Most of the men were serving in the Confederate army, the stores and post office were closed and the railroad was running only one train per week. When he arrived in town as the new Presbyterian pastor in 1864, Dr. Jacobs provided the following description of Clinton:

> *There were six streets in the town. The Main street running East and West (now dignified by the name of Carolina Avenue) had but few homes on it. The first in the town to the East end was Col. B.S. Jones's. Half a mile nearer the station was the Presbyterian church. Mrs. J.M. Fairbourn, Mr. Daniel T. Compton, Mrs. Robt. Owens and Bob Franklin's (on the corner of Broad,) were the only families on the south side, east of Broad. West of Broad the families were Mr. A.J. Butlers, H.M. Martin, Dr. Passly and Mr. Bob Williams. With the exception of Mr. Newton Young's home now occupied by Mrs. J.C. Copeland, these were the only families living in that part of Clinton…On the Main street, north of the Railroad, the first home*

Reverend William Plumer Jacobs, 1864. *Courtesy of First Presbyterian Church.*

was Mr. R.S. Phinney's. Mr. Elbert Copeland lived next to him, and Mr. Joel Foster ran a hotel which had been occupied a long time before it was finished and it never was finished. Beyond the stores and westward, the houses were those of Mr. Barksdale, Mr. Bell, Mrs. Langston, Gentleman Jno. Little, and no others. On Musgrove Street the only residences were those of Mr. Mad Ferguson, Mr. Tom Dean (the Mayor) and Mr. George H. Davidson. On Broad street, north, lived Mrs. Eustace, Mr. Huette, Mr. Harris and Capt. Leake. These were all. Mr. Harris' house was afterwards bought and owned by Dr. W.A. Shands. The only other street in the town was Pitts Street on which Mr. Bailey's Bank is now located. The only persons living on the street at that time were the Inglesbys, a refugeed family from Charleston. A little off, almost out of town, lived Squire Sloan at the end of the road, running out from Pitts street. These families constituted the entire white population of the town of Clinton.

As for businesses, Dr. Jacobs lists the following in his diary: Phinney and West, dry goods; Joel T. Foster, hotel; Copeland & Bearden and William Rose, groceries; Craig & Tobin and Bailey, general merchandise; W.D. Johnson, buggy factory; Robert Huett, wagon factory; Richard Huett, harness factory; Johnson, Huett and Young, blacksmithing; W.B. Bowen and George Davidson, carpentry; George Davidson, gin maker and tinner; Joseph Crews, combination sawmill gristmill and flour mill; D.T. Compton, George Simpson and Nelson Hood (African American), shoes; Mrs. Burgess and Mrs. Huett, millinery; William Butler, tailoring; Dr. Lon Harris, Dr. William H. Henry and Dr. Richard Dunlap, physicians.

The war had affected the supply of goods in town; with cloth scarce, almost every home had a spinning wheel and loom. According to Dr. Jacobs, Esther Fairbourn (or Fairborn) even had a room for raising silkworms. No Federal troops ever came into Clinton, although Dr. Jacobs remembers sitting on Robert Phinney's porch and watching the smoke rise as Columbia burned. Federal troops came up as far as Pomaria, only thirty-five miles from town, and Clinton experienced a flood of refugees from Fairfield, Lexington and Richland counties.

Many men from Clinton fought in the war. They served in a number of units, including Company F, Fourteenth Regiment, South Carolina Volunteers; Third Regiment, Kershaw's Brigade; First Regiment, Hampton's Brigade; First South Carolina Infantry; Company E, Fourth Battalion; and

Company A, Thirteenth Regiment. Many were wounded and several died, including Robert S. Owens, Ewell T. Blakely, George W. McDowell and Jonathan G.A. Holland.

RECONSTRUCTION

The Civil War had a disastrous effect on South Carolina. The state found itself $2.5 million in debt. There had been huge losses of livestock, and land values had plummeted almost 60 percent by 1867. Over 30 percent of the state's young men had been killed, and many others were permanently disabled. Nearly half of the state's wealth had been invested in slaves, and when Laurens County's thirteen thousand slaves were freed, planters found themselves without much of their wealth and almost all of their labor. The slaves, on the other hand, had little education, owned no land and had no way to make a living.

In response, most slaves entered into sharecropping or tenant arrangements, often with their former owners. Under the tenant system, renters had their own tools and animals and rented the land from the owner. Under the sharecropping system, former slaves were given a small piece of land; in return, they agreed to work the owner's land. (They often grew a small crop of their own, too.) It was hard for anyone to succeed under either system. All of the money earned by the workers from their personal plots went to pay the landowners for food, supplies, clothes, tools, seed and fertilizer. The landowner, on the other hand, had to borrow in order to buy these supplies in the first place, with no guarantee of a good harvest with which to repay the loans.

Freedom brought other changes for African Americans. Prior to the war, slaves were sometimes admitted to their masters' churches as members, but they either sat in separate slave balconies or attended special services provided for them. Slaves who belonged to the Associate Reformed Presbyterian Church sat in a room adjacent to the sanctuary during services. Dr. Jacobs added the first black members to the Clinton Presbyterian Church in May 1864. By the end of that year, he had added fifty-three slaves to the congregation. He held separate biweekly services for them, and since they could not read, he devised a special method for his services, which he recorded in a small book:

On entering the Church, I take my stand before the pulpit, open with a short prayer, then sing two verses of a familiar hymn & after that review last Sunday's catechismal lesson in about five minutes. Then I raise my hand—the class rises & we sing two or more verses of a hymn. They then resume their seats & I go over the next lesson with them. Then I teach them the text I am to preach from, & ask for last Sunday's text. After that we study a hymn together; try to sing the hymn. During this singing I go into the pulpit. After the singing, I take my text, the congregation repeating it & all the heads of my discourse &c &c after me. I conclude with a prayer, in which all unite in repeating the Lord's Prayer, a hymn and the benediction.

By 1874, Dr. Jacobs had confirmed a total of 150 black members. After the war, he began to perform marriages for former slaves and baptize their children. Between 1865 and 1873, he performed fifty-nine marriages and baptized thirty-nine infants. In August 1872, the Presbyterians organized a mission Sabbath school for their black members. Fifty people attended the first class, and ninety-five were at the second. A year later, the school was still flourishing, with forty-two members attending services each Sunday afternoon.

Most former slaves, however, had no desire to remain in white churches. Thousands of blacks across South Carolina organized their own denominations or united with northern branches of Baptist, Methodist and Presbyterian churches. A large number of black Baptist churches were established in the state, eventually organized under a statewide convention in 1876. By 1874, black Presbyterians in Clinton were organizing Sloan's Chapel, under the leadership of Reverend Daniel Gibbes of the "northern" Presbyterian church. By 1880, Sloan's Chapel had its own building, one hundred members and a school.

The period of Reconstruction, which lasted in various forms from 1865 until 1877, was chaotic at both the state and regional levels. Immediately after the war, the state legislature passed new "black codes" that gave former slaves some rights but imposed strict regulations on their movements. The first Reconstruction Act (1867) abolished the state government and placed South Carolina in a military district with North Carolina. General David Sickles, who was in charge of the district, eventually declared the black codes invalid.

Blacks were first allowed to vote in the state in November 1867; at the time, Laurens County had 1,628 whites and 2,372 blacks. This black majority,

coupled with high black turnout, resulted in the approval of a constitutional convention to be held in January 1868. Under the new constitution, all male residents over twenty-one were given the right to vote. Only women, paupers, prisoners and lunatics were denied the vote. The constitution also established a new public school system for children between the ages of six and sixteen. All public schools, including colleges and universities, were open to students of all races. There was, however, no real attempt to establish integrated public schools. In June 1868, Congress readmitted South Carolina into the Union. The following year, the state legislature passed a civil rights bill intended to enforce the provisions of a similar bill already passed by the United States Congress.

Partially in response to the new state constitution, white residents organized a chapter of the Ku Klux Klan in York County in the spring of 1868. The organization quickly spread across the upstate area. In his diary for February 15, 1871, Dr. Jacobs noted that "sixteen men were killed last week in Union County. They were all negroes, taken out of jail and hanged by the Ku Klux. God help our wretched land." Although it cannot be proven that the Klan was active in Laurens County, there were groups of vigilantes in the area. Night riding, intimidation and poll obstruction kept almost half of the registered black voters from the polls in Laurens County and other parts of the state. Even so, the elections of April 1868 produced a government dominated by blacks, carpetbaggers and "scalawags" (white southerners who supported the federal government's plans for reconstruction).

Despite the political turmoil, there were some developments in Clinton. Immediately after the war, Dr. Jacobs undertook a new venture that laid the foundation for the printing industry in Clinton. In 1866, he bought type and a small printing press and began publishing the *True Witness*, a four-page semireligious periodical, in a log building behind his house. He later moved the office to the Craig building on the northeast corner of Pitts and North Broad streets. He briefly terminated publication but later began putting out *Farm and Garden*, whose title he later changed to *Our Monthly*.

Clinton got a new charter in 1868, and business was beginning to pick up. The post office reopened, with Henry M. Martin serving as postmaster. J.Y.H. Williams's store was open once again, and S.L. West was offering Chester white pigs and Brinly plows. M.S. Bailey's store on Musgrove Street was open, and R. Russel was offering tailoring nearby. C.E. Franklin had

VOL. I. CLINTON, S. C., MAY 9, 1866. NO. 2.

REDUCTION IN PRICES!!!

J. Y. H. WILLIAMS,
Agent,

INTENDS to dispose of his present stock of goods on hand at a

Considerable Deduction

on former prices.

The scarcity of money in the Country and the great anxiety of merchants to get rid of their goods, bought at high prices, is an inducement for the merchant to offer

CREDIT.

The subscriber having tried both

THE CREDIT & CASH

systems, is thoroughly convinced that the

CASH!

system is the best both for the purchaser and merchant. He has determined to adhere strictly to the old rule;

CASH ON DELIVERY;

and to sell goods at prices that will justify the people in patronising him. He has a general assortment of

Dry Goods,
SUCH AS
CALICO, MUSLIN, LAWN, Barege, Crape Maret, White goods, JACONET AND SWISS MUSLIN, CAMBRIC, CORDED MUSLIN, Organdies, Plain & Embroider'd H'dk'f's, HOOP SKIRTS, BALMORALS, Ladies' Hats; &c., &c.

For Gentleman's Wear;
I have Cottonades, Linen Ducks, and Drills, Brown Linen, Cassimeres, and Cloths, Hats, Caps, Boots, Shoes, &c. 3t

CAMPBELL LODGE, NO 44, A.·.F.·.M.·.
Will hold its next regular communication, on Friday, May 25, 1866.
By order of the W.·.M.·.
 Jas. A. Dean, Sec.

We will take

OLD BANK NOTES

at New York Valuation, in exchange for our goods.

Craig & Tobin.

A Nice Lot of

READY-MADE

Clothing, at
Craig & Tobin's.

POTWARE,

Extra Lids, and Scythe Blades,
AT
Craig & Tobin's.

REMEMBER

TO CALL IN
AT

PHINNEY'S

Old Stand, where You

Can supply all your wants, at greatly reduced prices. The firm have determined, by strictly adhering to the CASH system, to sell at short profits, so as to make quick sales. tf

Gents' & Ladies'

SADDLES.

CRAIG & TOBIN.

A large lot of

TIN-WARE,
& CROCKERY.
Craig & Tobin.

Bargains for the People!!!

THE Subscriber begs leave to inform his friends, and the public, generally, that we intend to dispose of our present stock, on hand, at greatly REDUCED prices. The fact that goods are declining, makes it necessary that we should dispose of our stock at once, without regard to cost prices, in order to make room for a new purchase. Our stock consist of

Dry and Fancy Goods,
BOOTS & SHOES, HATS & CAPS,
LADIES HATS.
Hardware, Cutlery,
WOODWARE, CROCKERY,

Groceries of all kinds.

We feel confident that we can make it to the interest of the public to give us an early call, as we are determined to sell at Low prices.
 M. S. BAILEY & CO.

GEO. C. SIMPSON,
AT HIS OLD STAND, ON THE CORNER WEST OF FOSTER'S HOTEL

KEEPS constantly on hand a full supply of Hemlock, Oak-tan, English Kip and French Calf-skin.

Also, Shoe-pegs, lasts, shoe-nails, bristles, awls (handles and blades,) boot webbing, a large lot of Shoe-thread, &c.

Orders executed with neatness and dipatch. Prices low, and for cash. tf

SADDLE & HARNESS
SHOP AT CLINTON, S. C.

I would respectfully inform the citizens of Clinton and the vicinity that I have opened a shop, for the purpose of doing all kinds of work in the Saddle and Harness line.

All work entrusted to me will be executed with neatness and dispatch. Give me a call. I am confident of being able to satisfy all who may favor me with their patronage, not only as regards the quality of my work, but also as to prices. J. N. F. BASS.

Advertisements from the *True Witness*, May 9, 1866. *Courtesy of Presbyterian College.*

VOLUME FIRST, From JULY to DECEMBER, 1867,

FARM AND GARDEN.

AN AGRICULTURAL NEWSPAPER.

Devoted to the Improvement of our Sunny South.

PUBLISHED MONTHLY,

BY

JAS. R. JACOBS & Co.,

CLINTON, S. C.

Title page of the first volume of *Farm and Garden*, 1867. *Courtesy of Presbyterian College.*

Mercer Silas Bailey, early Clinton merchant and founder of the Bailey Bank and the Clinton and Lydia cotton mills. *Courtesy of Presbyterian College.*

a confectionery and grocery store, and photographers Wren and Wheeler were temporarily offering to take *cartes de visite*, ambrotypes and ferrotypes above Dr. J.T. Craig's store.

According to Dr. Jacobs, the railroad closed down completely in 1868, when the last engine rolled over into a ditch. Efforts were made to revive it in 1869, but it had closed again by 1870. By 1869, R.N.S. Young and R.R. Blakely had opened new general stores. By this time, there were a number of kerosene lanterns around the town square. W.S. Teague was advertising as an agent for the velocipede, an early form of the bicycle.

One of the big events in town was the annual anniversary celebration of the Presbyterian Sunday school. This occasion was first celebrated on May 9, 1868, the fourth anniversary of the school. In the minds of the children, who all had new clothes for the event, this celebration rivaled Christmas. It was attended not only by church members but also by crowds from the surrounding area. In later years, a procession formed in front of Dr. Jacobs's house at Thornwell Orphanage and marched to the church carrying banners. Children from various departments of the Sunday school

presented songs and recitations, and prizes were awarded. This was followed by dinner on the grounds.

Despite signs of normalcy, however, unrest continued. The Republican government authorized new state militias in 1869, which enrolled mostly black members. Lieutenant General Joe Crews, a former slave trader, was in charge of a large regiment of militiamen in Laurens County, one company of which was headquartered in Clinton. Apparently, he traveled around the county, accompanied by armed troops, greatly unsettling the white population. In 1870, the state issued Crews almost seven hundred rifles and eleven thousand rounds of ammunition for his troops; some of these arms were stored in Clinton. In response, nightriders swept through the upstate, especially in Chester, Laurens and Spartanburg counties, attacking both white and black Republicans.

The year 1870 was an election year, and tensions ran high that fall. On September 19, Dr. Jacobs described an incident that occurred in Clinton:

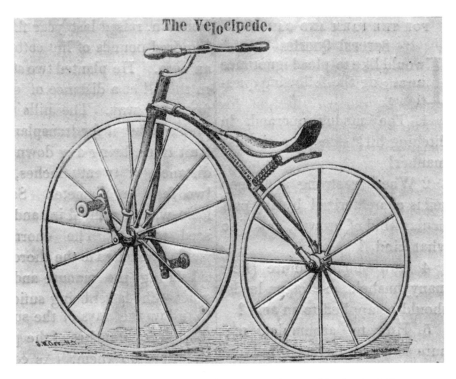

Illustration of a velocipede from *Farm and Garden*, 1869. *Courtesy of Presbyterian College.*

Advertisements from *Farm and Garden*, April 1868. *Courtesy of Presbyterian College.*

Last night after the sweet pleasures of the Holy Sabbath we were startled by rumors of an attack on Clinton by the negroes, 200 of whom had gathered at the mill, entered Joe Crew's armory and armed themselves. The whites assembled at West's store to the number of 75 and having armed themselves, awaited the attack. The poor women were scared half to death and many of them assembled at Mrs. Phinney's for protection. By God's good providence a collision has been thus far averted. But the races are in a highly excited state and I fear that evil will yet result from it.

Two days later, he gave the following report:

We have had a time of it. The whole cause of the fracas was the collision of a party of white and colored men near Clinton on Saturday night. The negroes fired on the white men. Their fire was returned and four were wounded. The negroes immediately assembled at the mill with three day's rations…The whites immediately began to assemble at Clinton and by eleven o'clock yesterday over a thousand men had assembled on the public square whereat the negroes became very much alarmed and agreed to go home and behave themselves. By night, however, a hundred men had again collected, the whites having dispersed. But they were notified by the guard of fifty whites who had been left in town that they would all be arrested unless they dispersed immediately and they immediately began to scatter. So ends the affair, I trust.

The election itself apparently came off without incident in Clinton, but the following day there was a riot in Laurens, which Dr. Jacobs described as follows:

Alas! My poor country! Our troubles are increasing. The election was held on the 19th and the negroes cheated us out of it. This excited the whites and on Thursday a fisticuff between a white man and a constabulary brought on a general row in which two negroes were killed. The passions of the whites were then aroused. The whole district flew to arms. All the guns belonging to the negro militia were seized, Joe Crew's office was torn to pieces, his papers were all destroyed, his furniture wrecked. Then began the reign of violence. Yesterday morning two dead men, one the radical probate judge was found dead at Milam's Trestle; and Wade Perrin, a colored

member of the House of Representatives was found dead at Martin's depot. Two negroes were also killed in the Rocky Spring neighborhood...Our whole land is thoroughly demoralized. Soldiers have been marching up and down our district arresting with most glaring injustice peaceable citizens and dragging them to Columbia.

John A. Leland of Laurens reports in his memoir that George Copeland, "the wealthiest merchant in Clinton," was arrested in January 1871. Apparently, bail was posted, and he was never brought to trial. In March of that year, the federal government sent additional troops to the state. Later in the year, President Grant called on all armed groups to disband and suspended the writ of *habeas corpus*. Dr. Jacobs noted that Grant had charged the county with "insubordination and Ku Kluxism." In the winter of 1872, the violence was so bad in Laurens County that some state legislators requested permanent military troops to quell the "reign of terror."

By late winter, prosecutors were arresting people across the county. On March 31, 1872, Dr. Jacobs noted in his diary that "six or seven of our best young men and Bob Williams, one of our deacons, were this morning arrested by the military on the charge of murder. Of course, the charges are as false as they can be." By late April, Dr. Jacobs was busy taking down testimony in Laurens to help the prisoners, who had been moved to Charleston. By early May, however, everyone was out on bail.

In late October, there was another wave of arrests. According to Dr. Jacobs, "On last Friday morning the constables came down and arrested a dozen of our peaceful citizens and took them off to jail. Like the chills, this is so common, we have got used to it. While the arresting was going on we held a meeting in full sight of them." Again, the men were soon released pending trial. In December, Dr. Jacobs actually went to Columbia to testify at the trial. George Davidson, Dr. Craig, Elihu Young and Charlie Franklin were eventually released because of a mistrial.

By the early 1870s, the Republicans had drastically increased taxes, particularly on landowners. This was a period of rampant graft and corruption across the South, and South Carolina was sorely afflicted. By 1873, there was a national depression, partly brought on by outrageous interest rates. Landowners and tenants had to rely on merchants to advance food, fertilizer and other supplies until the crops were harvested in the fall. In the meantime, the merchant took a lien on the future crop. If the crop failed,

the merchant was left with the debt, and as a result, it cost farmers between 20 percent and 50 percent more to buy on credit than to pay cash.

There were, however, some signs of progress in Clinton. N.A. Green had built a steam sawmill, and J.W. Leake had a water mill for grinding corn. Dr. Craig was running a brickyard. E.T. Copeland had a buggy and wagon factory. Mr. Bass was making harnesses. Mr. Davidson was a gin maker and turner. Mr. A. Mark (a native of Poland) was making boots and shoes. Mr. Fritz was manufacturing and repairing tinware. Some citizens had organized a Grange, and Mr. Rose had built three buildings on the public square.

Education was in short supply. In 1866, Mrs. S.Y. Robinson began to teach both boys and girls in the old academy building, but she left Clinton six years later. The state did initiate direct support of public schools during the 1870s, although it was sporadic at best. Laurens County's first superintendent of education, Pratt Suber, was an African American and presumably a former slave. He served until 1876, when he was replaced by Drew Dial.

In 1872, the trustees of the former female academy met at Dr. Bell's store and organized the Clinton High School, an upper-level school for both males and females. The group raised money to improve the old Clinton Academy building and chose N.J. Holmes (son of Reverend Zelotes Holmes) and his sister as the teachers. The school was open by January 1873. Holmes was later succeeded by Stobo J. Simpson and still later by Reverend William States Lee.

By February 1872, Dr. Jacobs—with the help of W.B. Bell, R.R. Blakely, G.B. McCrary, J.T. Craig and W.C. Irby—had spearheaded the organization of a library society. The collection, which was shelved in Dr. Craig's store, included books on travel, history, science, poetry, art, literature, religion and fiction "approved by the Christian public." Each subscriber paid two dollars annually for the privilege of borrowing books. By 1873, the library had fifty-six books and one hundred magazines in its collection. That same year, it obtained the flag of the Musgrove Volunteers, the first company to leave Clinton during the Civil War. On May 9 of the following year, the flag was presented at a special Memorial Day meeting at the Clinton Presbyterian Church.

Dr. Jacobs, in *Our Monthly*, spoke of the town with pride:

> *Railroad or no railroad, we expect to have a pleasant, agreeable and handsome little village. There is now prospect of improving our already fair*

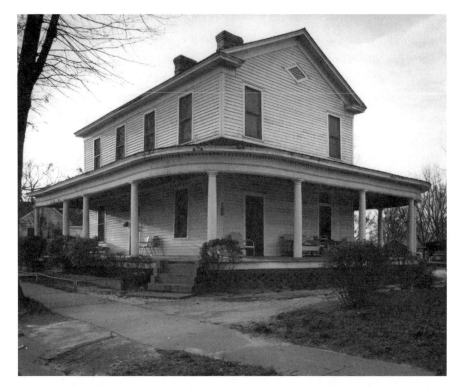

The academy building, original home of the Clinton Academy and Clinton College (later Presbyterian College). The porch was not original to the building. *Courtesy of Presbyterian College.*

educational facilities, our old rusty houses are being renovated and repainted. Our population is becoming less narrow-minded, more harmonious and more public-spirited. There is a dying out of the old bitterness existing between the two races. On the whole, Clinton is becoming a pleasant place to live.

On September 1, 1872, in a huge leap of faith, Dr. Jacobs and the session of the Clinton Presbyterian Church undertook a tremendous project. Dr. Jacobs proposed that the church establish an orphanage in Clinton, and the session asked him to draft a plan. He presented his report on October 21. He proposed that an orphanage for no more than forty children should be built within walking distance of the church, open to orphans regardless of the religion of their parents.

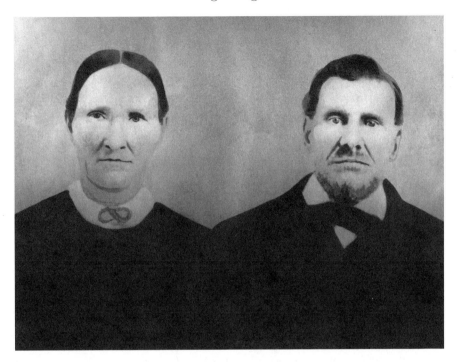

Susan Dillard Adair (1813–1886) and Edmond Adair (1814–1895). Ed Adair was operating a wool factory located slightly outside of Clinton in 1873. *Courtesy of Lawrence Young.*

This institution would run on the family principle, with part of the day devoted to study and the other part to work. Farms and workshops would not only make it partly self-supporting but would also train each child in a trade or occupation. The orphanage would be called Thornwell Orphanage in memory of noted Presbyterian theologian James Henley Thornwell. By the time the church gave its report to the presbytery in 1873, supporters had purchased R.H. Williams's farm for $1,600, and there was a newly appointed board of visitors.

By 1873, despite a financial panic, Mr. Bailey was planning to open a gristmill and sawmill. Ed Adair was operating a wool factory just outside of town, and young men had organized a debating club. Mr. C.E. Franklin was the librarian for the Library Society, and the books were now located above his store. Clinton once again had a visiting photographer in the person of J.E. Hunter. W.B. Bell was acting as Clinton's postmaster; he would receive a permanent appointment the following year.

In the fall of that year, Clinton, known for its barrooms, made a turn toward temperance. On September 10, a Lodge of Good Templars was organized during a meeting at the Presbyterian church. Indeed, Dr. Jacobs spearheaded this effort, and all of the original officers of the organization were Presbyterians. This caused quite a furor in the town. In May of the following year, Dr. Jacobs noted in his diary:

> *A war is being carried on by the bar-keepers against my church. Their daily occupation is to go round from one part of the town to the other, cursing the Presbyterians. They are doing their best to cause a breach and thank God, they will succeed. I have long hoped and looked for the time when a line…should be drawn between the Presbyterians and the world.*

By January 1878, the temperance forces had carried the day, and a prohibition ticket was elected in Clinton. An appreciative Dr. Jacobs declared, "We take pleasure in stating that hereafter all who wish to 'wet their whistles' in this place will have to make use of the town well." Clinton residents apparently managed to find liquor nearby, however. The *Laurensville Herald* noted that "Clinton had a large delegation at this place last Tuesday, some of whom looked very 'dry.' Laurens gets a better trade from that rural town since the 'Dry Ticket' carried the day." In 1880, the state legislature prohibited the sale and manufacture of liquor within three miles of Clinton's depot.

Prospects that the railroad would reopen produced growth in the business district, especially on North Broad Street near Main. By early 1874, Mr. Bailey was demolishing his old store and building a new one on Broad Street. By the middle of that year, his confidence in Clinton had prompted him to build a second store and plan for a third. By November, Mr. Young had bought the old Crews steam mill and had plans to open a tannery. Mr. G.H. Davidson had put up the first icehouse in the area, and the cornerstone for Thornwell's first building, the Home of Peace, had been laid. In 1875, J.W. Copeland put up a large building at the corner of West Main and North Broad streets that featured Copeland Hall on the upper story. The Home of Peace opened for eight orphan children on October 1, 1875, with Reverend Jacobs serving as director and his wife, Mary, as matron. By 1877, there were fourteen orphans in residence.

Some interesting forms of entertainment appeared in town. For several years, a drama club provided performances. In 1874, a menagerie came

Home of Peace, Thornwell Orphanage. *Courtesy of Presbyterian College.*

through town, and in 1875, Dr. Jacobs noted that "Prof. Bond entertained the citizens of Clinton recently by manipulating upon a tight rope, stretched from the top of Rose's to Craig's building. His 'show' was a success, and his exploits drew repeated applause from the bystanders." By January 1876, the new depot (later the Seaboard Air Line Station) was almost completed. This would usher in a quarter century of prosperity in Clinton, spurred by peak cotton production, railroad expansion and the establishment of major industries, including the cotton mills.

On the political front, Republican rule was coming to an end. Red Shirt clubs were organized across the state to support the Democratic candidate, Wade Hampton. The club for lower Laurens County, headquartered in Martin's Depot (now Joanna), included many men from Clinton. Indeed, according to a list published in the *Clinton Chronicle* in 1927, R.R. Blakely of Clinton was the president of the club and W.B. Bell, the second vice-president. Other prominent members from Clinton included G.B. McCrary, M.S. Bailey, A.M. Copeland, R.S. Phinney, R.N.S. Young, W.D. Watts, J.W. Copeland, R.Z. Wright, J.J. Boozer, Dr. H.C. Wofford, Dr. W.C. Irby and George P. Copeland. Wade Hampton visited Clinton and spoke before an

audience of over 2,000 black and white men. At the time of the election in November 1876, Laurens County had a black majority of 585 voters. Despite this plurality, Wade Hampton defeated the Republican candidate. Although federal troops were stationed in town, there was no unrest. Over 200 local blacks voted for Hampton in addition to every white man in Clinton. Dr. Jacobs expressed the following views on the election:

> In South Carolina, the Radical party has ground the state to death with taxes…it has utterly destroyed the integrity of our courts and made stealing honorable…it has kept up an interminable strife—because the money wrung from the people in exhorbitant taxes has been openly stolen, as a rule, and not as the exception…labor has been utterly demoralized…it has become a crime to be a white man, and to shoot one down met with no punishment…full ten thousand colored men in this state voted for Hampton. They seemed as deeply interested in the election, as the whites. They were not bribed—they were not bullied into it—they were not threatened. But having been duped for ten years, they determined to be duped no longer. Their interest and ours is identical.

It should be noted, however, that the election results in both Laurens and Edgefield counties were contested, mainly because more ballots were cast than there were registered voters. In any case, federal troops began to leave South Carolina in 1877, marking the end of Reconstruction.

Chapter 2

PROSPERITY AND GROWTH

An Improving Economy

Beginning in 1876, there was sustained growth in Clinton. In February of that year, more of the McKelvy lands, lying between Thornwell Orphanage and the Presbyterian church, were divided up into lots and sold at auction. By June, a new street, called Centennial Street, had been opened through this area. That same year, several new stores opened in town. Kahn and Isemann opened a grocery, shoe and dry goods store. Dr. Barre of Newberry had a new drugstore and H.C. Mensing, a tailor shop. Yet another itinerant photographer, Mr. Culbertson, was working in town. The town had its first dentist, Dr. H.C. Wofford.

In July of that year, however, there was a large downtown fire that destroyed G.B. McCrary's store on the corner of Pitts and Broad streets, as well as a row of houses. Bailey's store and Wright and Fergusons, which were nearby, were saved by a bucket brigade. Brown and Smith, who were black merchants, also lost a portion of their goods. By the end of 1876, the Laurens Railroad had reopened as part of the Greenville and Columbia Railroad. There were three libraries in town—the Library Society (150 volumes), the orphanage library (200 volumes) and the Presbyterian Sunday school library (1,100 volumes).

Thousands of bales of cotton were being shipped through town, and by 1878 Dr. Jacobs was already beginning to agitate for a cotton mill. By March 1877, there were sidewalks on all of the main streets and footbridges

across all of the ditches and drains. By the end of 1877, Reverend Morgan from Walhalla had opened a jewelry store, and M.S. Bailey was adding on to his store to produce the longest room in town—108 feet. Within two years, however, Bell and Young had constructed an even larger building, which housed the stores of T.C. Sumerel and R.N.S. Young. James Clary of Newberry was practicing law. There were four schoolteachers, and John W. Young, J.J. Boozer and W.C. Irby were practicing medicine. There was even talk of forming a new county, Hampton County, with Clinton as the county seat.

By 1879, the town's population had grown to 511—including 284 white residents and 227 black residents. Over five hundred acres of the Holland family's land, which stretched along Main and Adair streets, was divided into twenty-three lots and sold. There were several new businesses in town: S. Steinberg was making shoes; A.D. James was doing sawing, grinding, ginning and planing; and E.H. Boum, Mr. Bishop and several black workmen were doing carpentry. By the following year, Mrs. Amelia Jones and Mrs. Hampton had opened millinery stores, and Professor Hawkins was giving vocal lessons. In 1881, Mr. Hampton opened an ice cream parlor and soda water fountain, and M.S. Bailey, who already had a flour mill, opened a steam cotton gin.

Clinton had some interesting town ordinances at the time. It was forbidden to drive or lead horses on the sidewalks. Circuses were required to pay a license fee of fifty dollars per day, and each additional sideshow cost twenty-five dollars. It was illegal to damage or cut down a shade tree, even if the owner had planted the tree himself. Gambling and card playing were prohibited on Sundays, and all stores were closed on the Sabbath, except for drugstores, which could be open for one hour in the morning and one in the afternoon. Concealed weapons were prohibited, and no one was allowed to fire a gun within the city limits.

Between 1877 and 1890, the public school situation was dire. Most rural students attended one-teacher schools in dilapidated log or frame buildings. Some school terms were as short as two or three months. The public school system in Clinton itself was no better, and the town was fortunate to have private schooling available for both black and white students. By 1878, Dr. Jacobs reported that there were fifty-six students at the high school, twenty-five studying with Miss Ferguson, twenty-four at the orphanage and fifty at the "colored school" (Sloan's Chapel).

In addition to the Clinton High School for whites, there was also a Baptist academy in town, the Clinton Academy. Professor J.B. Parrott was in charge, and the school was run on a military model. By 1883, it boasted fifty-five students. Professor Parrott left Clinton for Waterloo in 1888, and Professor Jones took over the Clinton Academy. By 1891, Jones had apparently changed its name to the Clinton Classical Institute. There were other private schools in town over the years, run by Mrs. M.G. Humphries, Mrs. Price, Miss Sallie Winn, Mrs. Mary Lyles Simms and Miss Annie Spencer. At least some of these were for very young children.

In 1880, the foundation was laid for Clinton College (later Presbyterian College) when the members of the Clinton High School Association reorganized into the Clinton College Association. Since almost all of the association's members were Presbyterians, they transferred their stock to the session of the Clinton Presbyterian Church, which began to organize plans for a new college. The church session authorized the principal of the high school, W.S. Lee, to recruit a freshman college class, and former pastor Zelotes Holmes was hired as an additional professor. As for the younger students, the college offered preparatory classes, which served to replace the high school.

Progress at the college was rapid. The first class graduated in 1883. That same year, helped by gifts from trustees M.S. Bailey and J.W. Copeland,

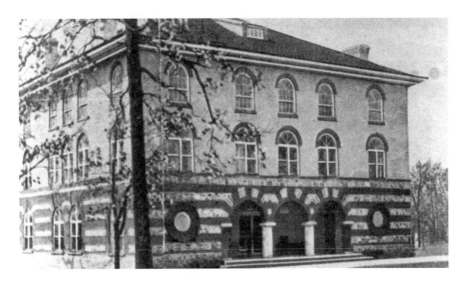

Recitation Hall. *Courtesy of Presbyterian College.*

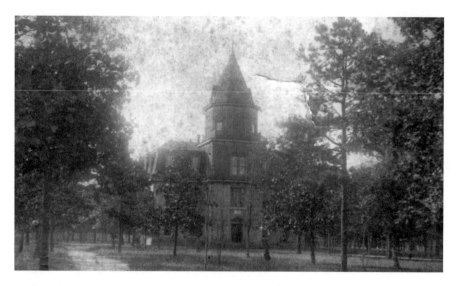

Thornwell Seminary. *Courtesy of Presbyterian College.*

the association raised enough money to buy four acres of land adjacent to Thornwell Orphanage. The cornerstone for the new college was laid in April 1885, and the imposing brick and stone building, named Recitation Hall, was dedicated in March of the following year. Thornwell Orphanage was also growing. Faith Cottage opened in 1881, and the following year the technical school opened. In 1883, the Orphan's Seminary at Thornwell opened. This building served as the first dedicated school building at the orphanage. It provided classrooms for primary, intermediate and college classes and included a chapel, a museum and a library. In 1886, the opening of the McCormick Home increased the capacity of the orphanage to forty-two, and the following year the print shop was opened.

Although Clinton apparently had telegraph service in earlier years, there was much excitement when the wires reached Clinton proper in 1881. Dr. Jacobs observed, "On the tenth of November, the telegraph wires reached Clinton; on the 12th the battery was put in and the first message sent." Mr. William Milnor was operating the telegraph, and Mr. G.B. McCrary sent out the first wire. In the spring of 1883, Dr. Jacobs's son, Ferdinand, began offering ferrotypes for twenty-five cents at his new photographic gallery on the corner of Centennial and Broad streets.

Some residents were experimenting with raising fish in ponds for commercial sale, but by 1884 these ventures had failed. Mr. Davidson

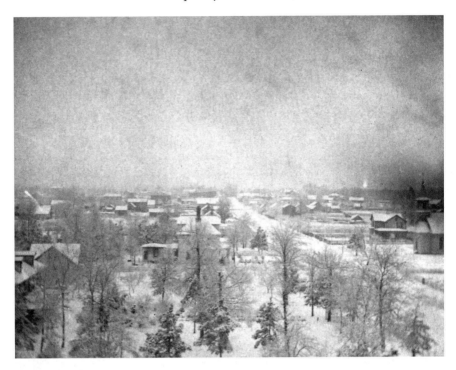

Early view of Clinton in the snow. Photo by Jacobs Photographers, Clinton. *Courtesy of Presbyterian College.*

complained, "Everything in nature destroys [my] fish, even to bullfrogs and spiders!" By the next year, the ponds, which lacked flowing water, had disappeared, having been condemned by the board of health.

Progress also continued on the religious front. In 1880, local Methodists replaced their original frame building at the corner of West Main and Laurens streets with a larger one. Friendship AME Church, in the Gideon Hill section of Clinton, and Bethel AME Church (now New Bethel), located two miles from Clinton, were organized that same year. By 1881, Bethel had what Dr. Jacobs described as "a shapely and large new church." This building would be replaced in 1890 and again in 1906. The 1906 structure included a school for children that was open for four months of the year. Hebron Baptist Church was organized in 1883 by fourteen former members of the New China Church, which was located just outside of Clinton. The congregation met in a brush arbor, and then at the Presbyterian church, until their new church on North Broad Street was completed in 1892.

By 1884, both Friendship AME Church and Hebron Baptist Church were conducting schools for black students. The Friendship School existed well into the twentieth century. For many years, classes were held in various houses, including the old church parsonage. The older students attended classes in the "old hall" (probably the Oddfellows Lodge), which was also used for assemblies. Until the early 1920s, only students in grades one through eight attended.

Entertainment remained simple. There was a snowstorm in December 1876, and the snow stayed on the ground for two weeks, making sleigh rides very popular. The skating rink was also a well-liked spot, causing Dr. Jacobs to warn that "such amusements always become harmful when they lead you to neglect religious or home duties." By the spring of 1883, the town boys had given up kites in favor of baseball, and by July the bicycle had arrived in town. Other forms of entertainment included evening parties, hot suppers, bazaars, ice cream festivals, lectures, exhibitions and dramatic charades. Many of these were held as benefits for the various churches and schools. Unfortunately, after fifteen years, the Library Society disbanded, and in 1887 the books were added to the college's collection.

In late January 1884, a large downtown fire destroyed McCrary and Ferguson's cotton warehouse and C.E. Franklin's store on the corner of Main and Musgrove. Apparently, hard work by residents prevented a larger conflagration. Dr. Jacobs noted, "It is impossible to speak too highly of the self-possession and willingness to help of all classes in the Community. The colored people worked like heroes and deserved the heartiest well-done of our town. There were young ladies, too, who toiled at the buckets and did good service."

There was further improvement in Clinton's railroad system. In 1885, the Columbia, Newberry and Laurens Railroad was chartered to connect Columbia and Laurens. It reached Newberry in October 1890, and by the following year it extended within two miles of Clinton. The Greenwood, Laurens and Spartanburg Railroad was organized in 1885; the Greenville and Laurens Railroad, which was later owned by the Port Royal and Western Carolina Railroad, opened the following year.

In 1885, M.S. Bailey decided to open a bank, the first in Laurens County. Bailey's Bank, which later became M.S. Bailey & Sons, opened on Pitts Street on February 1, 1886. Mr. Bailey's son, W.J. Bailey, was put in charge of the business department. The bank was advertised as absolutely burglar-proof and fireproof. Prior to this time, area residents were forced to buy everything on credit; with the opening of the bank, they could borrow at much lower rates.

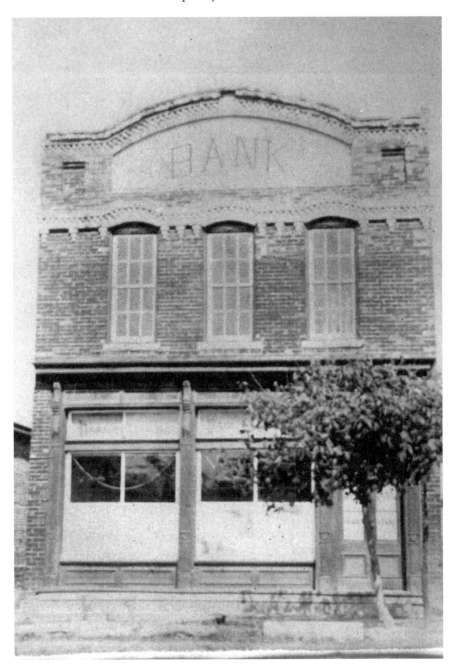

Bailey Bank, founded in 1886. *Courtesy of Presbyterian College.*

William J. Bailey. *Courtesy of Presbyterian College.*

Dr. Jacobs, in the April issue of *Our Monthly*, had the following to say about M.S. Bailey's success:

> *Twenty years ago in the neighborhood of Clinton might have been seen a poor, but honest and industrious young man, who borrowed fifty dollars on which to get married. Utterly without means, except his honesty and his energy, this young man faced his fate. He succeeded. Today he stands at the head of the property holders of Laurens County, and what is better still, he occupies that same high position in the esteem of his fellow-citizens. That man is Mr. M.S. Bailey.*

In 1885, Dr. Jacobs got his first typewriter and began using it to write *Our Monthly*. In May of that year, Mr. Wofford opened the Clinton Combination Company, a telegraph line connecting the south side of the city with the public offices. In March 1886, a new jail opened on Pitts Street, opposite the city market. Baseball was becoming increasingly popular with the young men and boys, prompting Dr. Jacobs to warn that "in some cases this is to

the neglect of study. Take care of the nobler things, boys, as well as those that are only for fun." In 1887, Dr. John W. Young, who had been practicing medicine in Clinton for the past decade, opened Young's Pharmacy. He owned the business until 1897, when he sold it to his son, Dr. Jack Holland Young. The business was a fixture in downtown Clinton for many years.

Among the most popular events of the year, along with the Sunday school anniversary, were the annual graduations at Thornwell Orphanage and Clinton (later Presbyterian) College. These were not just one-day affairs as they are now but rather lasted for anywhere from three to five days. Besides the usual commencement ceremonies, they featured a full program of recitations, debates, exhibits, speeches and sermons, which drew large crowds from the surrounding areas. Another popular event was the annual ball held by the Clinton Social Club.

Clinton, though, was not exactly an urban center. The public square, bisected by railroad tracks and cluttered with cotton platforms and warehouses, featured some of the most dilapidated buildings in town. During the decade, however, there were to be several additions to the downtown: L.H. Davidson's on West Main Street, the Sumerel and Briggs buildings on Musgrove Street and the Copeland and Stone building on East Main. While there were still no clear residential neighborhoods, there were new homes near Hampton, Woodrow and Broad streets.

On August 31, 1886, Charleston was severely damaged by an earthquake. Although the quake was centered near Middleton Place, and the area of maximum damage only covered approximately thirty miles, Clinton was apparently rocked by some of the many aftershocks. On November 3, Dr. Jacobs, who was in Europe at the time of the quake, noted, "We still have shocks of earth-quakes...hardly a day has passed since the 31st of August that we have not had a tremor. We are getting so used to them we hardly think to mention them unless an unusually perceptible shake occurs."

In 1887, the young men of the town organized a brass band. Although sources differ wildly, some putting the date as early as 1875, it seems that T.B. Crews started the *Clinton Enterprise* that same year. The newspaper was a weekly and cost one dollar per year. Professor J.B. Parrott was the editor. By March 1888, both Parrott and Crews had retired from the *Enterprise*; it closed but was bought later in the year by Wade Dendy and renamed the *Clinton Gazette*. Within two years, Dr. Jacobs was calling it one of "the fixed institutions of this town."

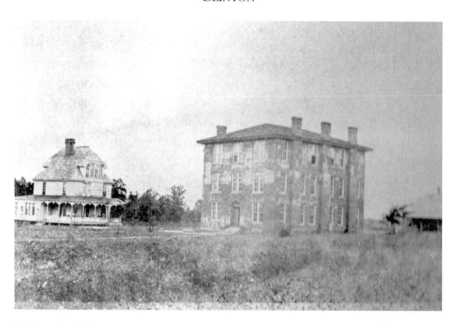

Presbyterian College campus, 1892. The Professor's Cottage is on the left, with Alumni Hall Dormitory in the center and the wooden dining hall on the right. *Courtesy of Presbyterian College.*

By 1888, officers had been elected for a building and loan association, and M.S. Bailey and son had established a sash, door and blind factory. The footbridges spanning the ditches and other wet areas were gradually being replaced by a system of terra-cotta piping. In 1890, J.W. Copeland and R.N.S. Young gave a fifteen-acre plot on South Broad Street to serve as the new campus for Clinton College. The main college building, to be built on the highest part of the lot, would be connected to Broadway (Broad Street) at Mr. Young's residence by a wide avenue. In 1890, the legislature granted Clinton a new charter under which the intendant (mayor) was now salaried, and the intendant and council served two-year terms. Elections, which had previously been held in January, were now to be held in October.

By the spring of 1890, railroad construction was tearing the town apart. According to Dr. Jacobs, the Georgia, Carolina and Northern (later the Seaboard) had "cut a clean sweep through Clinton" in 1885, and "now the Laurens Railway has literally torn things to pieces. The old ware houses, platforms, tracks and depot are all swept out of existence." He does note, however, that "a new and brighter order of things has taken place. The

improvement is very great...Never did our town have brighter prospects suddenly opened before it, than we have today." On August 20, workers, under the watchful eye of a large crowd of spectators, laid the last bit of track.

The busy rail lines were not, however, an unadulterated blessing. Some of Dr. Jacobs's complaints may sound familiar to present-day residents of Clinton: "Morning hours are now much disturbed by the shrill whistle of the locomotive. About 6:30, there are usually three trains coming and going, and beside that, the usual bustle of the working trains on the GC&N. Eight trains now arrive and depart from Clinton daily." All the development also caused land values to skyrocket, and Dr. Jacobs cautioned landowners "not to kill the goose that lays the golden egg."

By 1891, the town had five building and loan associations, the two newest being run by Dr. J.J. Boozer and W.B. Owens. M.S. Bailey had sold his woodworking business to D.A. Allen, who was originally a railroad contractor. In April, the Columbia, Newberry and Laurens Railroad was formally opened. By the end of the year, fourteen trains and several specials were running daily, including two daily mails from Columbia. By October, M.S. Bailey was building what Dr. Jacobs described as "the best equipped and most thoroughly finished" house in town. It was to be heated by steam, lit with gas and provided with water from its own waterworks.

A visitor from Atlanta, traveling through Clinton in 1892, had some very nice things to say about the town. In *Our Monthly* for September of that year, Dr. Jacobs reprinted the visitor's comments from the *Atlanta Journal*:

> *I was very much surprised yesterday afternoon...when...I started for a leisurely stroll over the pretty little city of Clinton. I had expected to see a country village...I was surprised at finding an elegant town of twelve hundred people possessing more industries than are usually found in a town of treble its size...The residences are nearly all two stories tall, painted white, and of beautiful styles of architecture...every appearance leads the visitor to believe that he is viewing a rapidly developing little city...The stores are nearly all of brick or concrete, large in size and beautiful architecture, most of them having glass or iron fronts and all possessing an air of business solidity...By looking on the map you will see railroads going out from Clinton in five directions and in this largely lies the prospects of this city for future growth...These lines and their branches give Clinton direct connection at Greenville and Spartanburg with the main line of the Richmond and*

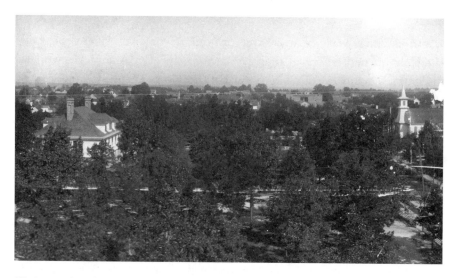

Clinton as viewed from the tower of Thornwell Seminary, sometime after 1883. Note the Baptist church on the right. *Courtesy of Presbyterian College.*

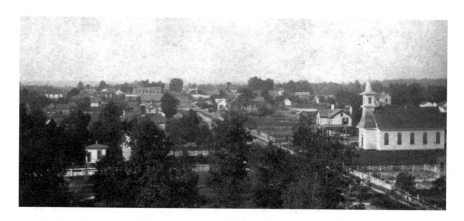

Clinton as viewed from the steeple at Thornwell. Jacobs Photographers, Clinton. *Courtesy of Presbyterian College.*

Danville, at Atlanta with nearly all of the roads of Georgia, at Norfolk, Va., with the chief lines of Virginia, at Columbia with several of South Carolina's leading roads, and at Charleston with the coast.

Among the thriving businesses mentioned in the article are the building and loan associations, a cotton ginnery, a marble works run by Mr. Smith and

Mr. Robertson, a buggy and wagon factory run by J.H. Little, the Clinton Warehouse and Fertilizer Company and the *Clinton Gazette*. A charter had actually been issued for a cotton factory, but it was not to open for several years, probably because of continued economic weakness. In conclusion, the writer observed, "The people of Clinton are noted for their intelligence, their culture and their business progressiveness. The town is particularly noted for its high moral character...The town jail is always empty and the various churches are crowded for every service."

In 1893, in the midst of a widespread financial downturn, D.A. Allen moved his manufacturing plant to Abbeville, and the town's dentist, E.O. Sims, announced that he was leaving. He was soon replaced, however, when H.C. Wofford returned to town and resumed practice. There were two gas plants in town, but each served only one dwelling. W.A. Shands retired as mayor and was succeeded by W.J. Leake.

The financial picture brightened in 1894, and John Young made plans to erect a large hotel building with more than twenty guest rooms and a large dining room. The hotel opened the next year, with Mrs. Peake in charge. In 1894, David Edgar Tribble opened D.E. Tribble Company, a lumber and building supply company. Over the years, Blakely Sloan and Russell Gray ran an undertaking business in the back of the building. Mr. Manuel Wax supervised funerals there for Clinton's black residents. M.S. Bailey and his sons were putting up the Clinton Ginnery, which would be able to turn a wagonload of seed cotton into a bale in only twelve minutes. G.L. and James Isaac Copeland opened a hardware store, which was later to become J.I. Copeland and, still later, J.I. Copeland and Brothers. There were losses to the business district, however, when the large buildings owned by Briggs and Sumerel and the Clinton Warehouse Company's building and contents were entirely destroyed by fire. Sumerel's was owned by Thad and Will Sumerel and stood on the Musgrove Street site later occupied by the Sadler Drug Store.

There were a number of new medical men in town. In 1895, Dr. W.H. "Hally" Young and his family returned to Clinton. By 1900, Dr. Young was marketing his chill cure, which could also be used as a tonic or blood purifier, as a cure for skin diseases, St. Vitus' dance and for general debility. John W. Young was still practicing medicine, and his son, James Lee Young, later joined him in practice. By 1896, Dr. James W. Davis had also come to town; he practiced for fifty-five years before retiring in 1951.

INDUSTRY COMES TO CLINTON

Factory fever struck Clinton in early 1895, when a group of enthusiastic citizens gathered at J.W. Young's drugstore to discuss establishing a cotton factory. R.Z. Wright, W.E. Owens and J.P. Little were asked to make plans and solicit contributions. By January 1896, the mill was organized, with M.S. Bailey as president and William J. Bailey as secretary/treasurer. The board of directors was made up of R.Z. Wright, W.P. Jacobs, P.S. Bailey, W.B. Owens and R.L. Bailey. By July 1896, the mill was under construction on Sloan Hill, near "Lover's Retreat." It was to be a three-story brick structure with an engine room, boiler rooms, a dynamo and a fan room and have a capacity of ten thousand spindles and 256 looms.

Workers would be housed in a mill village that would accommodate 150 people. In his memoirs, Joe Simpson notes that each of the streets in the village was named for a noted army officer, thus the names of Washington, Jackson, Lee and Beauregard. The Presbyterians soon had plans to open a Sunday school there under the supervision of Dr. Jacobs's youngest son, Thornwell. This Sunday school eventually became the Second Presbyterian Church. This church was short-lived, however. By

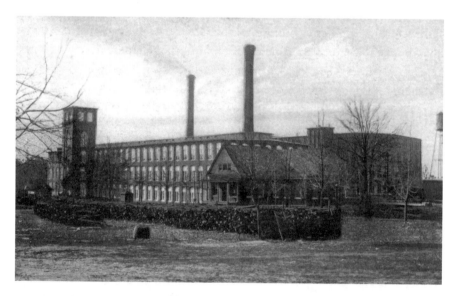

Clinton Cotton Mill. Postcard published by the American News Company. *Courtesy of Presbyterian College.*

1904, there were staffing problems; in 1912, the church building burned down, and the church was disbanded.

There were other changes in town during 1895. By September, Miss Annie Spencer was running a school for little children at the old academy, and Miss Eliza McCaslan was planning to open a kindergarten. In October, A.M. Copeland was elected mayor. Bicycles, which had arrived in town several years earlier, were all the rage. The craze spread quickly; in 1898, Dr. Jacobs observed:

> *"I've got a new bicycle" is the yearning wish of every Clinton gentleman and lady…This town is the town for wheels. The other evening, sitting on our portico, we timed the matter for five minutes. Nineteen wheels, two buggies, a wagon, and one lone pedestrian passed…Broad Street is the fashionable promenade for wheelmen in this young city of ours.*

By 1895, South Carolina had a new constitution, which provided for segregated public schools under the control of a state board of education. Schools were to be supported by a poll tax, surplus liquor money and property taxes. By the beginning of 1896, Dr. Jacobs was praising the public school in Clinton, which was open for nine months of the year. Mr. K. McCaskill was in charge, assisted by Mamie Sims and Annie Spencer. By July, however, the school was apparently in financial trouble, and students were required to pay. Later that year, Professor E.R. Aycock, who had been working in Jonesville, South Carolina, was put in charge. In 1899, the school board purchased the site of the old Clinton High School on Academy Street, and by 1902 work had begun on the new graded school building. In 1909, there was an additional school for grades one through three being run by Mrs. Baker in the mill village.

In February 1896, the engines were started at the cotton mill, an enterprise that would be central to Clinton for over a century. That same year, the residents of Clinton discovered the joys of the telephone. Bell and others had pioneered the innovation of the telephone in 1876, and the first exchange in South Carolina was established in Charleston in 1880. In 1896, the Consolidated Telephone Company opened an exchange in Clinton. In June, Dr. Jacobs declared that everyone was delighted with their new phones. But by August, he had some cautionary advice for users:

We were discoursing of family matters into the mouth piece of the telephone the other day, when we made the discovery that instead of our beloved across the way, we were interviewing a gentleman five miles off. Whenever you get to the Phone, it is well to remember that: If you your lips/Would keep from slips,/Five things observe with care./To whom you speak/Of whom you speak/And how, and when, and where.

By the turn of the century, L.W. Floyd Consolidated Telephone Company of Newberry was operating the telephone system. Soon thereafter, in 1902, Southern Bell bought the exchange, with its fifty-six telephones.

The printing business begun by Dr. Jacobs thirty years earlier was also expanding. In 1896, a joint stock company headed by J.F. Jacobs bought the *Southern Presbyterian* magazine from Dr. James Woodrow of Columbia and set up offices on the corner of Gary and Thornwell streets in Clinton. Under the editorship of Reverend Dr. W.S. Bean, the periodical was published in Clinton until it was sold to Reverend T.E. Converse of Atlanta in 1905. Meanwhile, in 1900, Jacobs invited all the editors and owners of the South's religious weeklies to join him in forming the Religious Press Advertising Syndicate. His brother, J. Dillard Jacobs, later bought a one-third interest in the company, which was renamed Jacobs & Company. Dillard sold his interest in 1912 and moved to Atlanta, where he established the Dillard Jacobs Agency.

In 1899, S.F. and James Parrott started a new newspaper, the *Clinton News*. The first issue was published on July 6, but in the following year the paper was moved to Laurens and renamed the *Laurens County News*. Clinton had an optician, Mr. Garvin. H.L. Todd, F.M. Todd and C.M. Todd of Simpsonville and F.D. Hunter of Greenville opened the Clinton Cotton Seed Oil Mill.

Clinton residents continued to enjoy a wide variety of amusements. Among the notable new events during this time was the Ladies' Aid Society Bazaar, which was first held in November 1898. In December of that year, Reverend Lewis and President A.E. Spencer of the college organized a series of five free lectures delivered by distinguished speakers. Summer amusements included picnics along the Enoree and Bush rivers.

Conditions worsened for South Carolina blacks during this period. African Americans had been permitted to vote, and had done so, since Reconstruction. In 1895, however, new regulations required voters to be able to read and write the state constitution; voters could be exempted from the literacy requirement if they owned property valued at $300 or more.

In addition, blacks were barred from participating in the Democratic Party primary, which was the only means of nominating candidates for office. (The right to vote in the primary was not restored until 1948.) Additional provisions of the law established separate but equal education systems and banned interracial marriage.

Crimes against blacks were widespread in South Carolina during the last quarter of the nineteenth century. During the 1880s, there was an increase in the use of the "lynch law" to punish alleged crimes. This reached its peak in 1898, when fifteen persons across the state were executed by mobs. In January of that year, a local farmer named Dave Hunter had a dispute with his landlord about the settlement of his yearly account. Subsequently, several men beat Hunter to death on the streets of Clinton with a buggy trace. No one was ever indicted for the attack.

A New Century

The first two decades of the twentieth century saw a boom in commercial building, extending the limits of Clinton's business district. One of the new buildings was the Utopia Building (now Hoyt Hanvey Jewelers) at 126–30 Musgrove Street, a massive structure built of molded concrete blocks. Others built before 1920 included the First National Bank of Clinton (101 East Main Street), the Bee-Hive Department Store (120–22 Musgrove Street), the City Station fire station and city hall (110 Musgrove Street), Jacobs and Company (123–27 East Main), the Masonic Temple (119–25 South Broad), J. Isaac Copeland and Brother Store (210 North Broad) and the Commercial Bank (200–202 North Broad).

At the beginning of the twentieth century, the South began to experience what was later named the Great Migration. This was a widespread movement of residents, mostly blacks, to the North, primarily in search of better employment. Between 1900 and 1910, South Carolina lost seventy-two thousand of its black citizens. Some of Clinton's black residents, however, were settling into town for the long run. In November 1905, Dr. Jacobs observed:

It is an evidence of the thrift of our colored population to see what a neat lot of buildings they are erecting in the West end of Green Street and out on

Advertisements from the *Collegian*, December 1902. *Courtesy of Presbyterian College.*

Lydia Mills avenue. They are literally taking that section of the town and are making it a nice looking place at that. It is in that section of the town that it is proposed to erect a colored Presbyterian church an enterprise, by the way, which our people should certainly help.

One of the up-and-coming black families in town was that of Young and Martha Dendy. Martha Duckett and Young Dendy Sr. had married in 1886 and had nine children. Young Dendy was a skilled carpenter, and in 1888 his wife established a laundry business that served PC students for many years. In addition to simple carpentry, Young Dendy also designed homes for some of Clinton's most prominent citizens, including George W. Young, George Ellis, J.W. Copeland Jr., Robert Hatton, Joe McMillian and Mrs. Hugh Workman.

There were a number of other black-owned businesses in Clinton. Turner Brooks Ferguson, a former slave, ran a blacksmith shop on West Carolina Avenue. Gideon Leake, also a former slave, had a large farm on the western side of Clinton. He later sold this land off in lots to create Gideon Hill. Reverend E.L. Lilliewood operated a barbershop and shoe repair shop, first in a home on West Main Street and later on Wall Street. He also owned a grocery store on Enterprise Street. Joe Simpson says that he "sold quality groceries, and enjoyed both white and colored trade." Milliken Wadsworth and his son, Clintt, ran a grocery store on North Adair Street that later became the home of Drucilla Wallace's famous Sno-Cones.

In 1901, Clinton had a new newspaper. While most sources say that J.F. Jacobs started the *Clinton Chronicle*, William Plumer Jacobs says that C.C. Little was responsible for launching the new paper. In *Our Monthly*, Dr. Jacobs described Little as "the venturesome, but public spirited gentleman, who has launched his bark, the Clinton Chronicle, on the troublous seas of journalism." Shortly afterwards, however, J.F. Jacobs joined him in running the paper. Editors who followed Mr. Little, some for only a brief time, included H.D. Rantin, A. O'Daniel and Robert S. Owens. When Owens resigned, he was succeeded by W.W. Harris. In 1912, Harris—along with Rantin, Allie and Arthur Lee of the *Laurens Advertiser*—bought the *Chronicle* from Jacobs, and in 1916 Mr. Harris became the sole owner. He remained publisher until his death in 1955.

In 1902, work began on Clinton Mill No. 2. That same year, M.S. Bailey opened another mill complex, located two miles outside of Clinton. Named

the Lydia Cotton Mill in honor of his wife, it opened with four thousand spindles and 150 looms. Mr. Bailey was the president of the company, and his youngest son, Cassius M. "Cad" Bailey, was its treasurer. Cad Bailey headed the Lydia Cotton Mill and was instrumental in the development of the Lydia mill village. Dr. Jacobs observed in 1905:

> *Lydia Mills is a very interesting suburb of Clinton. It is a thoroughly well ordere[d] mill community, and though quite young is decidedly improving. Mr. C.M. Bailey, who is in charge is improving the place greatly. It is the only part of Clinton the streets of which are lighted by electricity.*

There were many other changes in town during this period. In September 1901, R.E. Copeland and C.W. Stone organized the Clinton Clothing Company, later the Copeland and Stone Company. It was to remain open until 1951. By early 1902, local Methodists were building a new brick church, which was completed two years later, and the Presbyterians were replacing their frame building with a stone one. Providence Associate Reformed Presbyterian Church, which dated back to the 1830s, moved from its location two miles west of Clinton to a new frame sanctuary on North

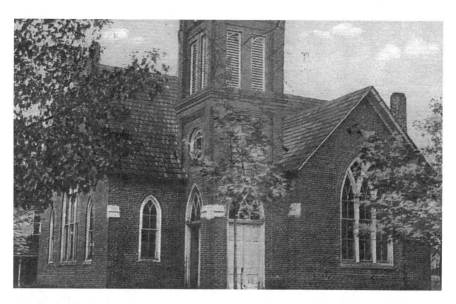

First Methodist Church, later renamed Broad Street Methodist Church. *Courtesy of Lawrence Young.*

Original frame building of the Associate Reformed Presbyterian Church, on North Broad Street. *Courtesy of Clinton Museum.*

Broad Street. In 1904, the First Baptist Church started a mission in the mill community. Originally called Second Baptist Church (and later renamed Calvary Baptist), by 1909 the congregation had a new building on the corner of Sloan and Jefferson streets.

There were other new churches in town. The Lydia Baptist Church, the first in the Lydia community, was organized in 1908. Members of the Clinton Fire Baptized Holiness Church (later the First Pentecostal Church) were holding services above a store in downtown Clinton by 1909. Shortly thereafter, they moved to a frame building on Jackson Street. In 1911, Robert Adair donated land near what is now Whitten Center so that the members of Mount Moriah Missionary Baptist Church, under the leadership of Reverend Walsh Boyd, could build a church.

Clinton itself had been under consistent leadership for a number of years. By November 1903, according to Dr. Jacobs, "Dr. W.A. Shands has been elected and re-elected and re-re-elected Mayor of Clinton for so long, that it really would not seem natural to have anybody else at the head of affairs." Some town laws were rather interesting during this time. They prohibited

leaving dead animals in places where they may become offensive...driving or riding at the rate of over six miles an hour...sales of merchandise on

Longtime mayor W.A. Shands.
Courtesy of City of Clinton.

the Sabbath, except drugs, articles needed for the dead, ice and milk; all mechanical and agricultural work on Sunday, and also all kinds of public sport and pastimes; selling fish and oysters on the streets...chicken-fighting, horse-racing.

They also prohibited concealed weapons and required residents to pay a fee for their dog to run loose.

The women of Clinton soon had their first social club. In 1903, Eloise Davenport Bailey, Mary Bailey Vance and fourteen other women organized the Actaeon Club, the first women's club in Laurens County and only the second in South Carolina. The club was named after a famous literary club in London, and meetings were held on the fourth Friday of each month. Mrs. Bailey was the club's first president and served for forty years.

Mary Bailey Vance, 1901. *Courtesy of Presbyterian College.*

In May 1904, the Presbyterian church celebrated its fortieth Sunday school anniversary. Dr. Jacobs described it as follows:

> *At ten A.M. the long procession 250 perhaps, had travelled from the seminary to the church. Forty prizes were given...There were songs by Orphanage and church chorus, by orphanage and church children. There were speeches by college boys. At eleven-thirty a special excursion of over 500 Columbia and Newberry people came in. The Columbians camped on the Orphanage grounds. The Newberrians proceeded to the college campus...Guests came to and fro—scores—hundreds—thousands. There was an impromptu "Musicale" in the T.O. Seminary.*

Fire struck the orphanage in early November 1904. Memorial Hall, built in 1889 as a kitchen and dining hall, burned to the ground. It took the fire over thirty-six hours to burn out, and the loss amounted to over $6,000. The citizens of Clinton, however, immediately stepped forward to offer provisions and home-cooked meals for the orphans.

The commercial district continued to grow. E.J. Adair, a native of Clinton who had been working for J.A. Bailey, opened a department store on Musgrove Street. It remained open until 1928, when he leased the space to J.C. Penney. Work was underway at one of J.W. Copeland's stores for the

First National Bank, which was to open in 1906, with J.S. Craig as president; R.Z. Wright and S.H. McGhee, vice-presidents; and J.D. Bell, cashier. By early 1905, Clinton had its first "nice and up-to-date restaurant." Dr. Jacobs, however, was disappointed that the city still lacked a fire department, a trolley line to Laurens, a city park, a city cemetery, an old folk's home and a Carnegie Library.

Clinton Mill No. 2 was being outfitted with machinery, and the mill owners were building fifty-five additional cottages for millworkers. Many tenant farmers were moving into the mills in search of better incomes. The economic advantages were obvious. In 1909, a tenant farmer could produce 15 bales of cotton in a season. He would get to keep half of his crop, or 7.5 bales. At $50 per bale, this would give him an income of $375. That same farmer, if three members of his family worked in the cotton mill, could make an annual income of $900.

Meanwhile, the citizens of Clinton were greatly concerned about the future of their college. In April 1905, the board of trustees decided to let other towns bid for the college's location. In August, Dr. Jacobs noted that "all feel distressed over even the suggestion of the removal of the college...It is very bad, indeed, for the town that established the College, that sustained it for twenty years...and that nursed the college all thro its years of minority, now to find, that they may lose it."

In September, the Synod of South Carolina spent two long days discussing whether to keep the college in Clinton or to accept one of the bids from other towns—Chester, Bennettsville, Yorkville (York) and Sumter. Reverend Parrott of the Baptist church was the chairman of Clinton's citizens' committee and spoke at the meeting. According to Dr. Jacobs:

> Col. Childs placed a special coach at the service of the Clinton delegation of about thirty...What about the enthusiasm of the Clinton delegation? Ask the boys...The enthusiasm began on the night of the 12th of September, when they stayed up most all night, calling people out of bed to the phones "double your subscription."

In the end, Clinton received twelve votes; Chester, six; and Bennettsville, one.

Presbyterian College coeds December 1909: 1. Frances Garvin, 2. Eliza Neville, 3. Mary Bean, 4. Frances Copeland, 5. Mary Dillard, 6. Kate Austin, 7. Mattie May Neville, 8. Anne Austin, 9. Blanche Adair, 10. Ruth Bailey, 11. Sarah Goldsmith, 12. Marjorie Spencer, 13. Barbara Richardson, 14. Helen Goldsmith, 15. Annie Blakely, 16. Bera Bailey, 17. Ellen Chandler, 18. Mattie Boland, 19. Emma Hipp, 20. Dorcas Mason, 21. Elise Spencer. *Courtesy of Clinton Museum.*

When the train returned from Columbia, all of the fire bells were ringing, and the whole town had appeared to welcome the delegation home. Saturday was spent in congratulations. "Every body quit business and called on the various members of the Committee…The accustomed 'good-morning' gave way on that day at least, to 'Well—good news. We've got the College.'" The celebration was capped off with a thanksgiving service at the Presbyterian church on Sunday night.

By the summer of 1905, there were three automobiles in Clinton, including Mr. Will Brown's. According to Dr. Jacobs, "The streets are lively late in the evening, with bikes, carriages and what the *News and Courier* calls benzine-buggies." The Fourth of July was celebrated with speeches, ice cream and cake, plays and fireworks. The Ladies' Aid Society chrysanthemum display and bazaar continued to be one of the highlights of the fall. Dr. Jacobs described it as "a very good substitute for a world's fair or an International

exposition, and about as interesting to the citizens of this community." Joe Simpson noted that it was held in Copeland's Hall and featured food, a wishing well and fortunetellers.

In November 1905, W.A. Shands was elected to serve his twentieth year as mayor. Three years later, Dr. Shands decided not to run for reelection, and Dr. Jacobs published the following tribute to him:

> *He has grown gray in the service of his fellow citizens and has given himself unremittingly to his duties. We think Dr. Shands' administration has been a wise and thoughtful one. Under his guiding hand the city has grown very naturally and sensibly and has made very rapid strides forward. In these twenty years, many new streets have been laid off and many great improvements effected. This includes the period of our railways and Cotton mills and the new growth of our College. It has given us telephones and electric lights and water supply.*

It was about this time that textile baseball first appeared in Clinton. The first mill game in South Carolina was played in Cokesbury in 1873, and by 1880 textile league baseball was becoming a popular sport. The first recorded games at Lydia Mill were played in 1906, when the team ended the season with a record of 0-3. Clinton Mills apparently first played the following year, ending with a record of 0-4. The teams improved greatly over the years, producing some professional players from their ranks.

In 1906, Dr. A.E. Spencer began to develop the part of town known as Bailey's Woods. This swampy piece of land—where Woodrow, Cleveland, Owens, South Adair and Calvert streets are now located—was a wilderness and hunting ground. Reverend J.F. Jacobs and Mr. George H. Ellis helped Dr. Spencer to drain it, and he decided to name the widest street in the neighborhood, Calvert Avenue, after his wife, Martha Calvert Spencer. Also in 1906, the city began planning for municipally owned water and electric works. The improvement in the water supply allowed the formation of a fire department, under the direction of Chief J.W. Copeland Jr. The city was reincorporated in 1906, and the new governance system provided for a mayor and six aldermen. About this same time, there was an auction of land north of Ferguson Street in northeast Clinton known as Owens Hill.

Dr. A.E. Spencer. *Courtesy of Presbyterian College.*

By May 1907, the houses of Clinton were lit with electric lights, and Dr. Jacobs proclaimed that "we are just as proud of them as we can be!" The town council soon installed electric lights on the streets, and arc lights in the more public areas. That same year, the businessmen of the town organized the Clinton Business League, and materials were delivered for construction of the new Union Station. Presbyterian College had a fine new administration building, Neville Hall, which remains the focal point of the campus today.

On May 10, 1907, the city observed Confederate Memorial Day for the first time. The daylong celebration featured a parade, speeches and the decoration of veterans' graves. According to Dr. Jacobs, this holiday partially replaced the annual Sunday school anniversary held by the Presbyterian Church:

$500 IN BEAUTIFUL PRESENTS FREE

GRAND AUCTION SALE

Choice Residential Lots at Owen Hill, Clinton, South Carolina

Friday and Saturday, December 1st and 2d,

at 3:00 o'clock P. M. Each Day on the Grounds

CONVEYANCES FREE TO GROUNDS BY ARRANGEMENT

FRIDAY and SATURDAY NIGHTS

COPELAND HALL 8:00 o'clock P. M.

REMEMBER THE TIME

OWEN'S HILL

Fronts on Adiar Street and is within the City Limits, beautifully marked off into residential lots. It is the highest point in the City Limits.

Warranty Deed will be Given each Purchaser

READ THIS CIRCULAR CAREFULLY

Come and Bring Your Friends. It will Pay You.

ESPECIAL INVITATION TO LADIES

Brochure for the sale of lots in Owens Hill. *Courtesy of Presbyterian College.*

Prosperity and Growth

For many years, the Presbyterian Sabbath School observed a regular day of Saturday for pleasure, collected great crowds of people to take part in its exercises. There was an out-door meal on the Church grounds and in-door exercises not altogether religious but with a tendency in that direction. Some two years ago (1906), it appeared that the Church was losing interest in the Anniversary, the stores however would do a thriving business, the households were staying at home to entertain company and even the children were taking more interest in the mere pleasure of the day than in the Sabbath School work. Thereupon, the session decided that tho the day was a pleasant one, it was not of the kind to be of any value to the school. The Anniversary was dropped as a Saturday affair and Sunday morning of the Second Sabbath in May was made a day of real religious work to the school. But the citizens of Clinton did not lose the day as a day of secular entertainment. It is now our memorial day, observed on Friday instead of Saturday.

By August 1908, Clinton had two hundred real estate owners, fifty of whom were black. There were half a dozen new buildings planned around Calvert Avenue, and the black neighborhood of town was also growing. According to Dr. Jacobs, "Even our colored citizens are on a move. The road out to Lydia Mills is lined with new and neat cottages…They have also put up a lodge room of two stories." That year, there was a severe flood on the Enoree River. While Clinton itself was not damaged, there was extensive damage to the old Musgrove Mill and Riverside Cottage, both of which were owned by Thornwell Orphanage. By 1909, the new Union Station was ready, and Dr. Jacobs described it as a beauty.

It is to be provided with pavilions so that passengers can change cars dry-shod. It is fitted up with all modern conveniences. It is lighted beautifully with electric lights, has large grates that nicely warm up the waiting passengers, has been fitted out with the latest style railway station seats, has fountains and flowers and palmettoes; is beautifully constructed of red pressed brick with stone trimmings and tile roof and is just a daisy.

In February 1909, Clinton saw the true benefits of its new fire department when Captain Duckett's house caught fire. According to Dr. Jacobs, two things were evident on this occasion:

Postcard of Union Station. Published by the Clinton Pharmacy. *Courtesy of Lawrence Young.*

The celerity with which five prayer meetings could disband and…how well our fire department could do the work. In fact, it was their first inning and they met the occasion quite handsomely. It gives everybody in the young city a sense of security to find how easily an ancient dwelling with its roof in one big blaze, can be put out by a fine volunteer fire department and a fine water system.

In May 1909, the teachers and pupils of Thornwell Orphanage left the First Presbyterian Church and organized the Thornwell Memorial Church—163 members were enrolled, leaving 300 members at First Church. In September, William Plumer Jacobs was installed as pastor, giving him responsibility for both churches as well as the orphanage. The First Baptist Church, in the meantime, was erecting a new brick building.

The Clinton Board of Trade had adopted the new motto "Watch Clinton Grow." And there was indeed growth. A.V. Martin organized the Citizens Building and Loan Association, which also included Clinton Realty and Insurance. Dr. Jacobs established a new periodical, the *Thornwell Messenger*, under the management of Reverend J.B. Branch. Clinton had a new club, the Avalon Club, for young bachelors. Headquartered at the corner of Musgrove and Ferguson streets, the club began as a sort of boardinghouse

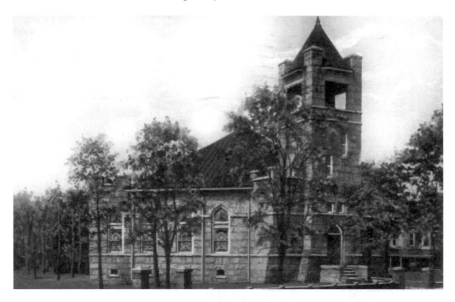

Thornwell Memorial Church. *Courtesy of Presbyterian College.*

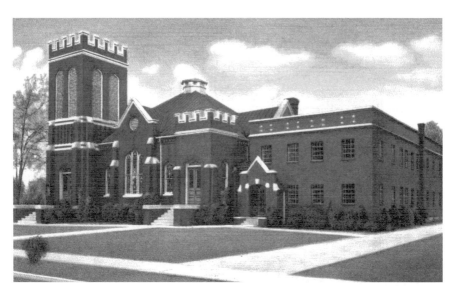

First Baptist Church, second building, built 1908. Genuine Curteich Postcard, Chicago, issued by the Chamber of Commerce, Clinton, South Carolina. *Courtesy of Lawrence Young.*

Confederate Monument and Union Station, circa 1911. *Courtesy of Clinton Museum.*

for members and later made rooms and meals available to the general public. The house was run by Misses Mattie and Tensie Blakely, and charter members included Albert Galloway, Eugene Forshe, Hugh Simpson, Tom Spratt, Robert C. McLees, Neil Turner, Hugh Leaman, John Spratt, Carl Barksdale and E. Blakely Sloan.

Early in 1910, the United Daughters of the Confederacy contracted with Milling Granite Company for a twenty-seven-foot-high Confederate monument, the first public monument in the city. The monument was dedicated on January 19, 1911—Robert E. Lee's birthday. Apparently, electric power had until this time been available only at night. In March, Dr. Jacobs remarked that "a day electric current is being put on, and the good housewives are arranging to run their sewing-machines and their smoothing irons by electric power." By May, he observed that "electric fans, electric toasters, electric smoothing irons are getting to be household necessities."

In 1910, Clinton once again had a library when the Clinton Public Library Association was organized under the leadership of Mr. E.H. Hall. W.S. Bean was appointed librarian, and the collection of 150 books was housed over the Bailey Brothers' Store. By 1911, the society had over one hundred members, and the collection included several hundred volumes. By November of that year, there was also a Clinton Cotton Mill Library.

The public library's first paid librarian was Miss Julia Neville, who served from 1912 until 1918. That year, the library was taken over by the Civic Improvement Association, which was later renamed the Clinton Women's Club. Financial support was provided by the club's $1 membership fee, as well as a $100 yearly contribution from the City of Clinton. There was also a new, brick school building on the corner of Academy and Elizabeth streets equipped with ten large classrooms, a library, an assembly room for five hundred and a heating plant.

Commercial development continued. Mr. Tribble was starting work on a new four-story hotel on Phinney Avenue (East Main Street), complete with baths, room telephones, elevators and electric lights. By early 1911, however, this unfinished project was under new ownership. (In 1914, it was bought by Jacobs Press.) Plans were also underway for the Commercial Bank, which opened in October in the Wright Building at the corner of Broad and Pitts streets. In June, Colonel William Jennings Bryan of Nebraska came through

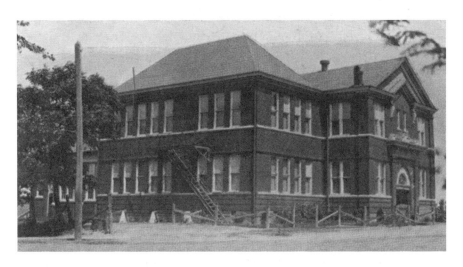

Academy Street Grammar School. Postcard, Jacobs & Company, Clinton, undated. *Courtesy of Presbyterian College.*

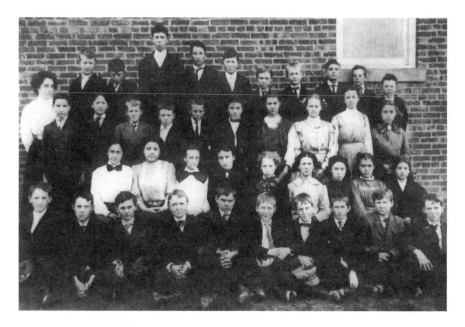

Seventh and eighth grades, Academy Street School, 1910. *Courtesy of Clinton Museum.*

Clinton, and Dr. Jacobs gave him a tour of the orphanage and proclaimed himself "decidedly pleased with him." Bryan, who had lost the presidential election in 1908, was part of the Chautauqua lecture circuit and spoke in LaGrange, Georgia, about this time. He was also a devout Presbyterian and may have had an interest in the orphanage. In July 1910, Dr. Jacobs resigned as pastor of the First Presbyterian Church after forty-seven years. However, he remained head of the orphanage and pastor at Thornwell Memorial.

In 1911, the city passed $45,000 in sewer bonds and $20,000 in water bonds. Two new grocery stores were opened by black businessmen, including Lilliewood's Grocery on Musgrove Street. There were two wholesale groceries in town, the Dixie Flour and Grain Company and the Milling Grocery Company. J.F. Milam was running the Clinton Carriage and Garage Works.

The two newspapers, the *Gazette* and the *Chronicle*, were both thriving. By May, the "moving pictures" had arrived in Clinton, and Dr. Jacobs noted that "the number of dimes that will drop into the till of that amusement will be past counting." There was also a new Chinese laundry in Clinton. In 1912, residents initiated yet another movement to form a new county, Musgrove County, with Clinton as the county seat. In November, four

hundred concerned citizens attended a meeting at Copeland Hall to listen to an address by Thomas B. Butler, who was instrumental in the formation of Cherokee County. The movement eventually failed, however, because of citizen apathy and difficulty raising funds for a new courthouse.

In 1912, the Home of Peace caught fire, but Captain Copeland and his fire department managed to save it. In 1914, the *Gazette*, which Mr. Dendy had sold to Lindsey and Foster Cromer, ceased publication. W.T. Crews revived it briefly, but his venture soon failed. That same April, the circus came to town "and gave the people a day of opportunity to get rid of their dimes, quarters, halves and other change," according to Dr. Jacobs. New streets were laid off in the eastern part of Clinton, and J.I. Copeland was preparing to sell the surrounding lots at auction.

By summer, there were more automobiles, and even an airplane, in town. According to Dr. Jacobs, "This is the year of automobiles. We learn that some of our fellow citizens saw an aeroplane pass over the city a few days ago. We did not happen to see that phenomenon, but we live on a street where an automobile is passing every few minutes of the day."

In August 1913, Mayor McMillian was appointed postmaster, and Dr. J.R. Copeland replaced him as mayor. Clinton had its first street signs, and houses would soon be numbered, which would enable city delivery of mail the following year. Plans were afoot for a new post office to replace the one at 107 North Broad Street, next to Young's Pharmacy. There were difficulties, however, and by 1915, the government had still been unable to find a suitable lot.

In the fall of 1914, Mr. Tribble lost his wooden warehouse in a fire, and he replaced it with a brick building the following year. In August 1915, Bailey Brothers' double store was also destroyed by fire, with a total loss of over $50,000. Joe Simpson noted that the city's library was housed upstairs and that many books were destroyed, including a set of Horatio Alger books that he had been reading. That same month, the new brick Methodist church at the corner of North Broad and Ferguson streets was opened for worship. The building featured a dome and Corinthian columns, and its combined Sunday school and auditorium could seat more than five hundred people. By 1916, plans were afoot to build a new high school for white students on Hampton Avenue.

There was also progress in the black community. Sloan's Chapel Presbyterian Church congregation was still in existence, even though the building had blown

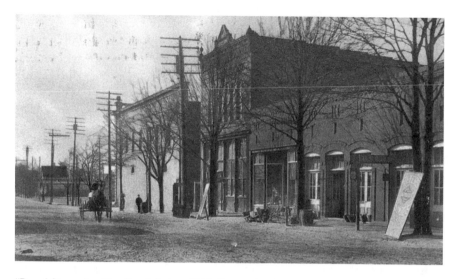

"Broad Street, Looking South," circa 1913. Postcard published by the Clinton Pharmacy. *Courtesy of Clinton Museum.*

First Methodist Church. *Courtesy of Lawrence Young.*

down several years earlier. In 1916, Herbert Thompson started a public dray company. For many years, he hauled goods for most of the businesses in town—first with a horse and wagon and, later, with a Model T truck. Educational opportunities for blacks, however, were severely limited. Dr. Jacobs, having

High school, Hampton Avenue. Postcard published by Rose's Stores, 1940. *Courtesy of Clinton Museum.*

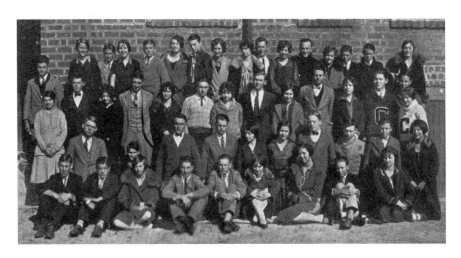

Junior class, Clinton High School, 1926–27. From the 1927 *Clintonian. Courtesy of Presbyterian College.*

been asked to visit the black school, found it crowded and declared that it "should have better housing and the colored teachers more encouragement."

In the fall of 1916, Dr. Leslie St. Clair Hays, who had a clinic above a store on North Broad Street, announced plans for the city's first hospital.

Clinton Hospital, 1919. *Courtesy of Presbyterian College.*

The three-story brick building, on the corner of East Carolina and Hays streets, was completed the following year. The hospital featured steam heat, eleven private rooms, two four-bed wards for whites and separate wards for blacks that would house ten patients. The operating room was equipped with the most modern sterilizing equipment. By 1923, Hays's hospital offered a three-year training course for nurses under the supervision of Mrs. Helen Hays. The hospital was equipped with an X-ray machine, a laboratory, an electric treatment machine and ultraviolet ray lamps. Several charitable organizations provided four free beds, one of which was reserved for employees of the Clinton Cotton Mill.

In addition to Dr. Hays, Clinton had several other new doctors during the first quarter of the twentieth century, including T.J. Peake, F.K. Shealy and B.H. Henry. Dr. Shealy arrived in Clinton in 1917 from Goldville (now Joanna) and was still practicing on Woodrow Street in 1947. Henry, a native of Clinton, opened his practice in 1919 and practiced until his death in 1949. There was also an African American physician in Clinton in 1919, Dr. Bernard N. Hatcher. Other doctors who opened practices during this period included James R. Copeland, M.J. McFadden, G.W.B. Smith, F.F. Hicks and R.W. Johnson. Dr. Hicks was still practicing in town twenty years later.

The city's fire and police departments were housed in a new building opposite Bailey's Bank. By 1917, Rufus E. Sadler and William Owens had opened a new pharmacy on Musgrove Street, where Adair's Men's Shop is

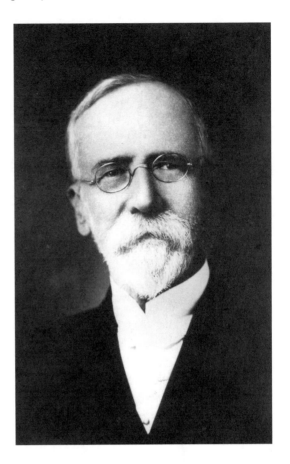

Dr. William Plumer Jacobs.
Courtesy of Presbyterian College.

now located. The Triple A Agriculture Company bought the cotton oil mill and switched production from cotton oil to dry fertilizer. One decade later, the Kershaw Oil Mill would change the factory back to cotton oil.

Dr. Jacobs died on September 10, 1917, and Clinton lost one of its greatest boosters. He was the impetus behind so many improvements: Thornwell Orphanage, Presbyterian College, the Library Society, the temperance society and even the cotton mills. The frail young seminary graduate who arrived in Clinton in 1864 had certainly left his mark on the town. He had also added immense flavor to the history of Clinton with the innumerable historical tidbits he wrote in his diary and in *Our Monthly*.

A WORLD WAR AND A DECLINING ECONOMY

WORLD WAR I AND ITS AFTERMATH

In April 1917, the United States entered World War I. During the war, fifty-four thousand South Carolina men were drafted. On the homefront, citizens supported bond drives, victory gardens and the Red Cross. The government instituted daylight savings time. Mondays were "heatless days," and many stores and mills were closed. Sugar was eventually rationed, and Americans voluntarily reduced their consumption of other goods with meatless Tuesdays, wheatless Wednesdays and porkless Thursdays. Many PC students left college to fight. In October 1918, the college also formed a Student Army Training Corps (SATC) unit, which was demobilized a month later when the war ended. This was soon to become the ROTC program, which was once required of all students.

The flu swept across the country in the fall of 1918; public gatherings were canceled and movie theaters and parks were shut down. Well over 100,000 South Carolinians contracted the flu, and between 4,000 and 10,000 died. Thornwell orphanage had over 200 cases of the flu, and Presbyterian College was also greatly affected. According to President Douglas, "Practically all of October was taken up in…taking care of the students sick with influenza. However, we did not close down in October; by the last of the month, everything was running smoothly."

The *Clinton Chronicle* published a number of interesting letters from local soldiers, including Sergeant Pierre Burdette, Oliver Lankford, L.C. Coggins,

Dr. James W. Davis during World
War I. *Courtesy of Clinton Museum.*

J.W. "Jack" Anderson and A.M. Young. J.W. Anderson, of Company B, 117th
Engineers, reported to his mother:

> *Mamma, I was at the front when the last guns fired. I hope it will be*
> *the last ones. It sure did seem strange to hear the guns all quiet down. It*
> *seemed more like a dream than it did peace, for I had been in hearing of*
> *them for almost nine months. We went in the front lines on February 26th*
> *and we have been in nearly all of the important battles of the Western*
> *front. We were in the battle of Champagne…then we went to Chateau-*
> *Thierry…to St. Mihiel. There I carried my platoon over the top with*
> *tanks and had four men wounded out of it. From there we went to the*
> *Argonne Forest. There we stayed until we reached Sedan. This is the*
> *place where we were when the armistice was signed…It made me mighty*

A World War and a Declining Economy

sad to hear of Lee Lex Copeland's death…But there has been a many one put to death over here, but it was all for a good cause.

On June 7, 1919, Clinton held a Jubilee Day in honor of the returning soldiers, featuring a parade of children, cars, floats and a band from Camp Jackson. This was a big event in town, as it was combined with a homecoming day and Chautauqua performances. Chautauqua programs, intended to bring cultural events to small towns, were an interesting feature of this era in America. By the mid-1920s, Chautauqua performers and lecturers were appearing annually in more than ten thousand towns in forty-five states. The performances were organized by different companies and were supported by the contributions of local citizens. Most of Clinton's performances over the years were put on by the Redpath Chautauqua. Offerings were numerous and varied. In 1924, for instance, Clinton residents were treated to two plays, an opera festival, a harp ensemble, Welsh singers, lecturers and children's programs.

Cotton markets sagged during the early days of the war in Europe, but after the United States entered the war in 1917, prices surged. During the war, the mills operated sixty hours per week, not returning to a fifty-five-hour week until March 1919. After the war, Clinton quickly returned to normal. By 1919, the Ellis Motor Company of Clinton was selling Hupmobiles for $1,450, and there was a Commercial Club under the leadership of President George M. Wright. By 1919, Clinton had a Boy Scout troop, and P.S. Jeans was operating a Pepsi-Cola bottling company in town. There were plans for a new three-story Masonic Temple, which would include stores on the first floor and the new Casino Theater on the second. And there was an interesting variety store in town, complete with a bargain basement, called the Hot Hustler Racket Store.

In March 1919, South Carolina announced plans for the State Training School for the Feeble Minded (later renamed the State Training School). The school, located just outside of Clinton, was funded by a state grant and was to be headed by Dr. Benjamin Otis Whitten. The facility, which had two dormitories, a farmhouse and a temporary dining hall, opened in 1920 with six male patients and a staff of four.

The Depression actually hit South Carolina earlier than it did the rest of the nation, about 1920. Most of the local farms were still running on the tenant system. The land had become increasingly depleted, and the boll weevil was

Above: Masonic Hall and Casino Theater, South Broad Street. Postcard, Jacobs & Company, Clinton, undated. *Courtesy of Clinton Museum.*

Left: Dr. Benjamin O. Whitten, circa 1920. *Courtesy of Clinton Museum.*

decimating the cotton crop. The advent of more modern farm machinery lessened the need for workers. Farmers could no longer afford to furnish their tenants with food and fertilizer. While many tenants were allowed to keep their houses, they were forced to fend for themselves. During the next decade, many rural residents moved into cities and towns, and even more, particularly

The front of a dormitory at the State Training School. *Courtesy of Clinton Museum.*

blacks, moved north in search of work. Between 1920 and 1930, the black population of South Carolina declined by 20 percent. In 1923, for the first time in a century, whites outnumbered blacks in South Carolina.

Educational opportunities were gradually increasing for black students. In the early 1920s, Friendship School added grades nine and ten; later, with the addition of the eleventh grade, Friendship became the only high school in Laurens County at which a black student could receive a state diploma. In 1924, the district awarded the contract for a new black school to be built on North Bell Street near Friendship. When the new building was completed, it became a county school and was named Bell Street School.

Despite the weakening economy, Clinton seemed to have good prospects. By 1924, the population was over four thousand, excluding college students and residents of the State Training School. The town had a sewer system and deep-well water, and many streets were paved. Several railroads ran through town, including the mainline of the Seaboard Air Line from Birmingham to Richmond. Main roads included the Piedmont Highway, which ran from Charleston to the North Carolina mountains. Plans were underway for the development of the Calhoun Highway, which would be part of the Bankhead route from Washington to San Diego.

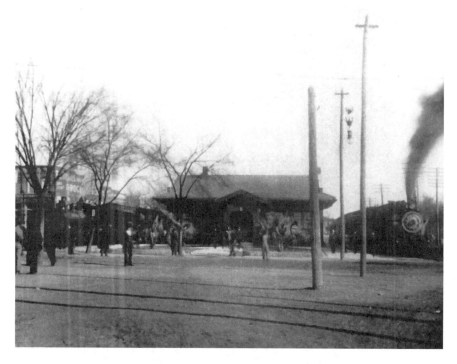

Clinton's depot with a CN&L train on one side and a Seaboard train on the other, early twentieth century. *Courtesy of Clinton Museum.*

Post office, North Broad Street. *Courtesy of Clinton Museum.*

Jacobs Press Building. *Courtesy of Clinton Museum.*

There were other developments in town. The new, long-awaited post office opened on North Broad Street in 1923. Jacobs and Company had a thriving graphic arts department, which offered photoengraving and electrotyping. It was one of the few presses in South Carolina to do halftone and color work. The Clinton Cotton Mill had seventy thousand spindles and 1500 looms, and Lydia provided twenty thousand more spindles. In 1925, C.W. Stone and B.H. Boyd filed to incorporate the Clinton Agricultural Loan Association, designed to provide farmers with credit at a 6 percent rate of interest.

Ferguson Ford, owned by E.W. Ferguson, opened before 1922. It was only the fifth Ford dealership to open in South Carolina. John Spratt of the Dixie Flour and Grain Company organized the Clinton Hatchery and Feed Company. There were also a number of thriving black-owned businesses in town. Among these was Elbert Beasley's Pressing Club and Laundry, located on the site of the present-day Wilson's Curb Mart.

Clinton also boasted a number of civic groups for men at this time. By 1921, the Order of Good Samaritans was working to care for the poor and sick and protect the community from the spread of contagious diseases. The Kiwanis Club, organized in 1923 and only the fifth club in the state, was holding regular meetings at the Clinton Hotel. Other groups included

"A Portion of the Business District." Postcard, Jacobs & Company, Clinton, undated. *Courtesy of Clinton Museum.*

the Knights of Pythias, which held an annual holiday banquet, and the Rotary Club. The Clinton Rotary often cooperated with the Laurens club for baseball games and amateur musicals like *The Flapper Grandmother*, which was staged in 1924. In the late 1920s, some of Clinton's men organized Niagara Tribe No. 52 of the Great Council of the Order of Red Men of South Carolina. This civic group, pledged to support freedom, friendship and charity, was organized outside Philadelphia in 1813 and had tribes in over forty-six states. The Clinton lodge had over one hundred members.

The women of Clinton were also organizing themselves. A group of women, hoping to raise funds in support of the public schools and the library, organized the Civic Improvement Association. In January 1925, another group organized the Century Club, which devoted itself to the study of a different subject each month. In 1927, the Women's Music Club, which was later to become the Wednesday Music Club, was organized. Charter members included Mrs. Cornelia Harris, Mrs. Henderson Pitts and Mrs. Collette Tibbetts.

There were numerous prosperous churches in Clinton during this period. Methodists led in membership, with 1,066, followed closely by the Presbyterians with 1,037 and the Baptists with 992. Others included the ARP with 90 members, the Holiness Church with 42 members, the Lutheran church with 37 and the Episcopal church with 13. Efforts had been made

St. John's Lutheran Church, Hampton Avenue. Genuine Curteich Postcard, Chicago, issued by the Chamber of Commerce, Clinton, South Carolina. *Courtesy of Lawrence Young.*

New Bethel AME Church. *Courtesy of Lumus Byrd.*

to start an Episcopal church as early as 1908. After this first effort faltered, Reverend S.R. Guignard renewed the mission effort in 1915, but it was suspended again in the 1920s. In 1920, Mount Moriah Missionary Baptist Church moved to its current location on Mount Moriah Church Road off North Adair Street.

St. John's Evangelical Lutheran Church, organized in 1920, had a new brick building on Hampton Avenue. About this same time, the New Bethel AME Church congregation built a large new frame structure. The Pentecostal church congregation, located in the mill community, constructed a new frame building, which was to serve them for the next seventy-seven years. In 1925, the Lydia Baptist Church began work on a new building on the corner of Poplar and Palmetto streets. A new Methodist church, named Bailey Memorial in memory of William Cyrus Bailey, was dedicated in the mill village in June 1926. Located at the corner of Bailey and Academy streets, it was led by Pastor T.A. Inabinet. The congregation had actually been organized in 1922 and had worshipped at first in Granny Jacks's store at the corner of Sloan and Jefferson streets and, later, in a house on the corner of Jackson and Bailey streets. There was one huge loss to the religious community during the '20s, however. In December 1929, the First Presbyterian Church burned to the ground during a severe ice storm. All that remained were the granite outer walls. The church was insured,

Bailey Memorial Church. *Courtesy of Presbyterian College.*

First Presbyterian Church following the 1929 fire. *Courtesy of First Presbyterian Church.*

however, and had been rebuilt by the following year. In 1931, the Hebron Baptist Church congregation built a new building under the leadership of Pastor A.A. Sims.

By the 1920s, textile league baseball was serving as an unofficial farm system for the major leagues. The mills in both Clinton and Lydia had teams and both produced stars. Charlie Wilson, who played for Clinton in 1920 and again in 1928, went on to play for Boston and St. Louis. Johnny Riddle played for Clinton in 1923 and later played for the White Sox, the Red Sox, Cincinnati and Pittsburgh. Clarence "Chick" Galloway, one of Clinton's stars, later played for the Philadelphia Athletics and the Detroit Tigers.

There were other notable events in the '20s. New neighborhoods were appearing near the college. In 1923, George W. Young drew up plans for the College View neighborhood. By 1928, the nearby property of William P. Jacobs II and John T. Young had been surveyed into lots for the Woods of College View, surrounding modern-day Young Drive. In 1928, the library was moved from the Jacobs Building, where it had been for several years, to the high school.

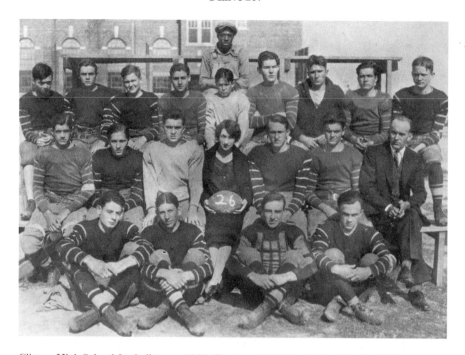

Clinton High School football team, 1926. *First row, left to right*: Arthur Copeland, Pete Bennett (captain), William Montjoy and Dick Vaughn. *Second row*: Parker Martin, Harry Davis, Bascomb Timmons, Miss Brown (sponsor), Sam Glenn, Clyde Trammel and E.M. Shannon (coach). *Third row*: Sidney Denson, T.J. Blalock, William Blakely, M.A. Sumerel, William Pitts, Virgil Abrams, Don Copeland, Albert Abrams and George Smith. From the 1927 *Clintonian. Courtesy of Presbyterian College.*

In 1921, Clinton had its first high school football team, coached by Lonnie McMillian. McMillian had already started a team at Thornwell and would later coach at Presbyterian College. By 1923, under Coach Jodie H. Hollis, the high school team was undefeated. In 1925, Presbyterian College became the home of the state collegiate track meet, which was held there until the 1950s. The annual meet, which was described in the college newspaper as featuring "Olympic color and pageantry," drew thousands of fans to Clinton. By 1924, Clinton had two Boy Scout troops, one sponsored by First Presbyterian Church and the other by Broad Street Methodist. Lydia Mills also had a troop. A new elementary school, designed by the Anderson architectural firm of Casey & Fant, was planned for a site on Florida Street.

By 1926, the city was planning a grand new city hall, also to be designed by Casey & Fant. It was to include fire and police departments, a banquet room, offices for city officials and separate jails for blacks and whites. Unfortunately,

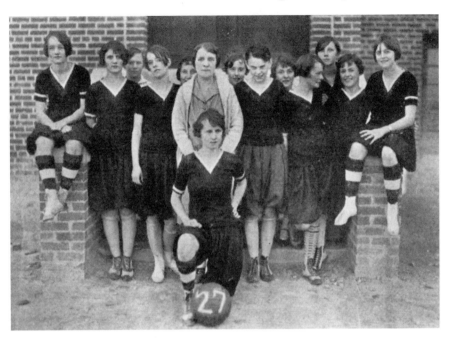

Clinton High School girls' basketball team, 1926–27. *Front, left to right*: Mary Todd, Elmira Ray, Alma Ruth Cooper, Miss Parks (coach), Lyde Copeland, Catherine Jones, Helen Chalmers, Janet Leake and Elizabeth Sheely. *Second row*: Ruth Carter, Helen Milam, Jeannette Crawford, Hazel Boland and Ella Little McCrary. From the 1927 *Clintonian*. *Courtesy of Presbyterian College.*

this plan never came to fruition. In April 1926, Dr. Hays's hospital burned to the ground. Within a year, he had announced plans to open a new hospital in the former J.W. Copeland home on Woodrow Street. The building was eventually enlarged with the addition of brick wings. While the new hospital no longer included a nursing school, it did provide ten rooms, wards for black patients, a dining room, a kitchen and a modern operating room. Rooms on the second floor provided housing for the superintendent, Mrs. C.B. Adair, and other nurses. The city's first multifamily housing was built across the street, echoing the brick construction of the new hospital.

In 1927, Stutz-Hadfield Silk Corporation of New York opened a plant to manufacture silk crepe cloth on Davidson Street. The plant originally opened with 54 looms but had space to expand to 130. Although the plant closed in 1935, the building was later occupied by Hallmark Shirt Company and still later by Anvil Brand Shirts and Gilliard Lingerie. In February 1927,

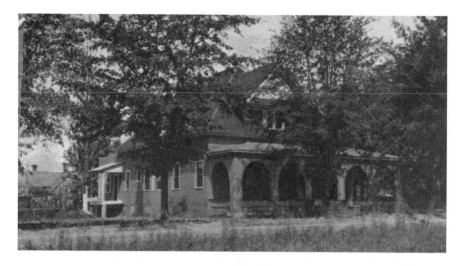

Hays Hospital, Woodrow Street, Clinton, before the wings were added. Postcard, Jacobs & Company, Clinton, undated. *Courtesy of Lawrence Young.*

Hays Hospital, Woodrow Street. Genuine Curteich Postcard, undated. *Courtesy of Clinton Museum.*

Southern Bell announced that it would occupy a new building on the corner of Broad and Gary streets, to be built by D.E. Tribble. Tribble opened a hardware store on the ground floor of this building, run by L. Russell Gray, an experienced hardware man from Laurens. Gray had also recently

graduated from the Cincinnati College of Embalming and would help with Tribble's undertaking business.

Later in the year, R.E. Ferguson, formerly superintendent of the Lydia Cotton Mills, opened the Industrial Supply Company, a wholesale dealer in mill supplies serving several states. Co-owners included members of his family, as well as J. Hubert Todd. In 1928, Miss Ella Adair opened her Ladies' Ready-to-Wear Shoppe, which operated for more than twenty years. That same year, B.F. Sumerel opened a department store that remained open until he sold his stock to Murray Garber of Laurens in 1951. Charles Clinton Giles also opened Giles Chevrolet on West Main Street in 1928.

The Great Depression

In late October 1929, the stock market crashed, marking the onset of the Great Depression. Banks around Clinton began to fail. In July 1929, the National Bank of Newberry, which was almost sixty years old, closed its doors. That October, there was a run on the Woodside National Bank in Greenville. On January 22, 1931, the First National Bank of Clinton closed its doors. According to the *Chronicle*, the directors took this action to protect depositors after an unexpected "run" on the bank. By late afternoon, it had been turned over to the comptroller of the currency. Another bank failure hit very close to home when the People's Enterprise Bank of Laurens failed in December 1931.

The textile business was struggling. C.M. "Cad" Bailey noted in his diary that "business is poor, can make no money, cotton too high for cloth—about 4 to 5 cents per pound apart—hope adjustment will come soon." Although millworkers at the time were better educated and better paid than earlier workers, and although they now benefited from improved public services and recreation facilities, there was increasing unrest in the textile industry. By April 1929, there had been strikes in Ware Shoals, Pelzer, Greenville and Union. In June, some workers at Lydia Mills went out on strike, but the majority of the workers stayed loyal to management and the strike was soon over. This unrest, however, foreshadowed more disruptive strikes in the 1930s.

Since the new city hall was never built, the police and fire departments and the city government moved into a building on North Broad Street. Textile

J. Harvey Witherspoon, superintendent of schools, 1920–35. From the 1927 *Clintonian. Courtesy of Presbyterian College.*

baseball continued to thrive, and the Clinton Mills team won the Central Carolina League championship with an 11-4 record in 1931. By 1930, there were six schools in Clinton, four white and two black. The number of students had doubled in the last decade, and school property was valued at $185,000. J. Harvey Witherspoon was superintendent of the Clinton schools at this time; he served from 1920 until 1935. In 1931, Guy L. Copeland's property on West Main Street was destroyed by fire. The property contained three buildings and housed Cato's Market, Miller's Music Store, Copeland's Café and the Copeland Hotel.

Franklin D. Roosevelt was elected president of the United States in 1932, and the following March, he declared a bank holiday. Both of Clinton's banks closed in observance of the holiday, but the *Chronicle* noted that "despite the closing, Clintonians fell into line and are carrying on business as usual, although in some cases it is on a limited scale." Due to the continuing agricultural depression, the government passed the Farm Credit Act of 1933, which authorized the establishment of local Production Credit Associations

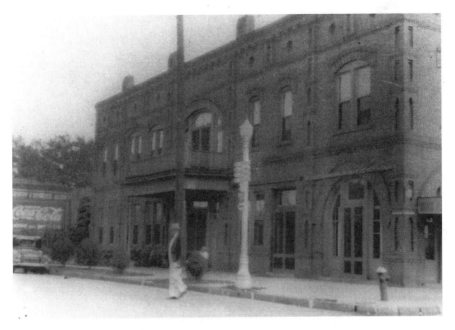

Clinton Hotel, corner of South Broad Street and Carolina Avenue, late 1930s. *Courtesy of Clinton Museum.*

for farmers. The Clinton Production Credit Association, headed by C.W. Stone, was chartered in December 1933. It operated for many years; in 1951, having repaid all the money advanced to it by the U.S. government, it became member-owned.

Clinton's second movie theater, the Broadway, opened in the summer of 1935. Like its sister, the Casino, it was owned by Dr. Jack H. Young and managed by Mr. Shealy. Clinton had a new Lions Club, organized in February 1932. One of its charter members, I. Mack Adair, was active fifty years later. The city also had a new National Guard unit, Battery G of the 263rd Coast Artillery, under the leadership of Walter Johnson. In 1934, a group of local citizens—including Dr. Jack H. Young, W.D. Copeland, Reverend Edward Long, John T. Young, W.W. Harris, O.I. Shealy, R.W. Wade, F.M. Boland, John H. Young, H.D. Henry and C.W. Stone—chartered the Commercial Depository of Clinton.

Economic problems continued in South Carolina, however. By January 1932, the state owed its teachers more than $1 million in back pay, in some cases dating back eighteen months. The textile industry was also affected by the economic downturn. Starting in December 1931, local mills closed

Florida Street School first grade, 1933. *Front row, left to right*: Clinky Winn, Alan Suddeth, Edna Baldwin, Katherine Baldwin, Bobby Turner, Marian Pitts, Mary Dean Holder, Marie Lawson and Bobby Dailey (standing). *Second row*: unknown, Billy Mahaffey, unknown, James Chandler, James Henry Ammons, unknown and Fred Burnette. *Third row*: Bobby Plaxico, Virginia Nabors, Miss Lilly and Norma, Ed Sadler, Richard Stutts and C.B. Sanders. *Back row*: Wyman Shealy, unknown, John Pitts, Charles Johnson, Jean McSween, Alice Poole, unknown and unknown. At rear, standing, is Billy Copper. *Courtesy of Clinton Museum.*

for two weeks to limit production and hopefully stop declining prices. By January, the mills were operating only three days per week, and owners across the state were meeting together to plan further curtailments.

South Carolina society remained racially segregated during this time. Although there was some agitation for civil rights by black soldiers returning from World War I, it was short-lived. The progressive movement had some effect on southern society during the 1920s, but almost all programs were aimed at whites. Even the New Deal reforms mainly affected white citizens; most businessmen, while willing to accept the government's standards for wages and hours, felt that they should apply only to white workers. And there had been no attempt to stop the use of the "lynch law" in the South, even though some newspapers were beginning to speak out against it. Indeed, in 1933, three black men were lynched in South Carolina.

Dendy family. *Front row, left to right*: Mary L. Dendy, Martha Dendy, Mattie Dendy and Viola Dendy. *Back*: Spurgeon Dendy Sr., William F. Dendy, David E. Dendy and Robert Dendy. *Courtesy of Clinton Museum.*

On July 4, 1933, Clinton was the scene of the last reported lynching in Laurens County. The victim was Norris Dendy, the thirty-five-year-old son of Young and Martha Duckett Dendy, mentioned previously. By this time, the Dendys had sent all of their children to college, and several of the children had become professional workers. One of their sons, David Dendy, later returned to Clinton as a school principal and became instrumental in having the Martha Dendy School named in his mother's honor.

Norris Dendy was married and had five children. On July 4, he took a truckload of friends to Lake Murray for the day. Another local resident, Marvin Lollis, did the same. Sometime during the day, the two men got into an argument about who had the better truck. Lollis hurled some epithets at Dendy, and Dendy threw a punch at Lollis. Norris Dendy's friends urged him to return home before there was further trouble. On his way back to

Clinton, the Joanna police stopped him for erratic driving, and instead of taking him to the Laurens County Jail, they took him to jail in Clinton.

That evening, his wife and mother went to the jail to try to bail him out. They were unsuccessful. In the meantime, a large crowd had gathered. About 10:00 p.m., while the police chief was at home and the guard out on patrol, some members of this crowd forcibly removed Norris Dendy from his cell and drove him away.

At the request of family members, police began a search, which was later called off because of darkness. The following day, Norris Dendy's body was found on the grounds of the Old Sardis Church near Renno. He was bruised and had a fractured skull, and ropes were found nearby. There was considerable outrage in Clinton. W.W. Harris, the editor of the *Clinton Chronicle*, called the crime "a discredit to the community" and "revolting to those who believe in law and order—an unwarranted act for which there can be no justification." The white pastors of Clinton also protested, calling it a "dastardly crime" that had caused "the fair name of our town to be heralded through all America and the nations of the world as utterly lawless and uncivilized." Indeed, the case was publicized in such national publications as the *Atlanta Journal*, the *Nation* and the *New Republic*.

The governor of South Carolina launched an investigation, and Norris Dendy's brother, Robert, who lived in New York, kept the pressure on local law enforcement. Five local citizens were accused, and two grand juries, one in February 1934 and one the following June, heard the case. Key witnesses were reluctant to testify, however, and no indictments were sent down. The grand jury's verdict was death "at the hands of a person or persons unknown," and the case never went to trial.

In 1933, the federal government launched the National Industrial Recovery Act, designed to reduce working hours, increase profits and wages, increase employment and give labor the right to bargain. The program was under the supervision of the National Recovery Administration (NRA). The NRA did not just govern textile mills; it applied to other businesses as well, including retail stores. Laurens County retailers unanimously agreed to a forty-hour workweek and were soon proudly sporting the blue eagle symbol of the NRA to indicate their compliance.

The Prewar Era

The National Recovery Administration sanctioned union activity, and more and more textile workers were joining the United Textile Workers (UTW). This, combined with fewer jobs and fewer work hours, caused increasing unrest in the textile mills. In 1934, over half of South Carolina's eighty thousand textile workers participated in the United Textile Workers strike, and seven workers were shot and killed at Honea Path. In May of that year, because of slumping sales, the government authorized the textile mills to cut production by 25 percent during the next three months. The mills were either to shorten shifts or reduce the number of days worked per week.

In September, four of the five major mills in Laurens County closed. Watts Mill and Lydia Mills were closed by strikers on Monday, September 3. Picketers closed the mill in Clinton on Tuesday. This put 1,100 workers out of work at Clinton and 600 at Lydia. The mills remained closed for almost a month, reopening in the first week of October. By the next week, there were four special deputies in Lydia, and mill authorities were moving to evict nine former employees—despite a nationwide agreement to rehire all workers who had not engaged in violence.

In November, W.J. Bailey, acting president of the Clinton and Lydia Mills, appeared before a hearing of the Textile Labor Board. Clinton Mills was charged with not rehiring four union leaders and Lydia with discriminating against eighteen leaders. By December, the board had asked the NRA to remove its blue eagle flag from the Clinton Cotton Mills. Mr. Bailey, unfazed by the request, stated:

> *If the government wants to take our Blue Eagle they will just have to take it; we do not intend giving those discharged workers their jobs back…we consider those men disturbers…we are not going to give jobs to disturbers who created dissension and brought about trouble during the strike…Before the NRA we employed 1100 persons. Now we employ 250 less. That is what the NRA has done for us.*

Eventually, an alternate union, the Clinton Friendship Association, was formed at the local mills, and all workers were invited to join. Those who refused lost their jobs. In a speech in Greenville in August 1935, John A. Peel of the UTW called the situation at the Clinton Cotton Mills "the most

flagrant violation of the national labor relations act that has come to my attention…The management of the Clinton Mills has used every form of intimidatory and coercive methods conceivable in establishing and managing their company union under the title of Clinton Friendship Association." Mill officials asserted that, while the mill was a closed shop, it was because the majority of the employees had chosen to join the Friendship Association.

A hearing was held in Greenville in late November 1935. According to the *New York Times*, witnesses charged that foremen and overseers in the Clinton mills had "stimulated the organization of the Clinton Friendship Association in order to eliminate the local union of the United Textile Workers." Subsequently, mill owners "refused employment to more than 165 union men who refused to join the friendship association." In mid-December, in a separate hearing in magistrate's court, management reached an agreement with the former employees that no eviction papers would be served until after the holidays, which would give the former workers time to relocate. Not one family vacated, and by early January the board had ruled that the mills should reinstate 95 workers and give them back pay. By the middle of the month, however, the mills had served eviction papers on 37 workers, and their belongings were put out on the sidewalk. Governor Olin D. Johnston responded by sending tents to be set up as temporary residences on nearby property.

In March 1936, the *New York Times* reported that the National Labor Relations Board had acted on the case. They "ordered the dissolution of a company union, the invalidation of a 'closed shop' agreement, banned the 'check-off' system of company union dues, declared the so-called 'contract' with the company null and void and ordered the reinstatement of discharged

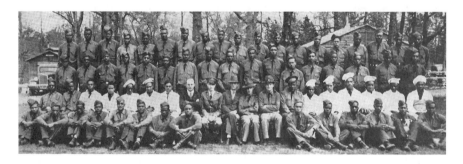

Members of Company 4465, 1936. *Courtesy of Clinton Museum.*

members of the United Textile Workers." This turmoil affected production in the mills, many of which ran only one day per week during 1935. Sales fell again in 1937 because of weak demand, and some shifts were cut in half. Economic weakness caused the mills to shut down entirely for three months in 1938. The industry did not return to profitability until World War II.

One of Roosevelt's attempts to deal with the economic crisis was the organization of the Civilian Conservation Corps. Camp SC-F-10, Company 4465, was located near Clinton and employed young men from two hundred families, most of them from outside South Carolina. Each family received twenty-five dollars per month for the young man's work. Projects included grading and resurfacing forest highways and putting out forest fires. There were also educational programs aimed at overcoming illiteracy and improving the skills of those who were already literate. Among the first 175 enrollees, 85 could not even sign their names. Night classes included reading, writing, math, civics, business law, bookkeeping, current events, public speaking, journalism, blacksmithing, motor mechanics and woodworking. The camp also had a basketball team, which won the colored championship for District I of the CCC, and a glee club, which performed in Clinton, Whitmire and other nearby towns.

CWS Guano Company. Photo by D.A. Yarborough, Clinton. *Courtesy of Lawrence Young.*

Armory, South Broad Street. *Courtesy of Clinton Museum.*

Despite the hard times, there were some new developments in Clinton during the late '30s. In 1935, a new Belk store opened on Musgrove Street under the management of D.B. Smith. Russell Gray, who had been working for D.E. Tribble, opened the Gray Funeral Home in the old J.I. Copeland home on East Carolina Avenue. By 1942, Gray was able to buy out Tribble's undertaking business. I. Mack Adair opened a clothing store, which moved to its current location in 1937. Duck Copeland, Chaney Stone and Reeder Workman joined John Stevens in establishing the CWS Guano Company, which supplied fertilizers and other farm products. Work began on a new armory, funded by the Works Progress Administration, on land given by John H. Young on South Broad Street; it was completed in 1937. Many residents of Clinton remember going to high school basketball games and dances there. About this same time, the Baldwin Ford Motor Company opened on North Broad Street opposite the post office.

In 1936, L.P. Dailey of Georgia opened the first nursery in Clinton, which provided landscaping in addition to featuring evergreens and flowering shrubs. The following year, Cooper Motor Company opened on West Main Street under the management of Lynn Cooper and Billy McMillian. In 1937, the Citizens Building and Loan Association was federalized, and its name was changed to the Citizens Federal Savings and Loan Association. Clinton Realty and Insurance continued to be part of the business. That same year, the Friendship AME Church congregation dedicated its new building on South Bell Street. In 1939, the Calvary Baptist congregation demolished its old building; the congregation dedicated its new church in

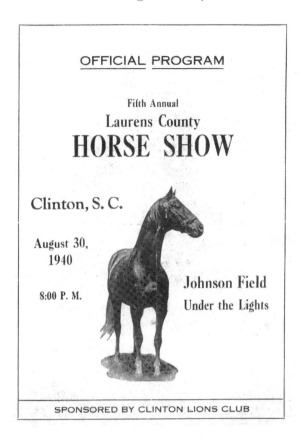

OFFICIAL PROGRAM

Fifth Annual
Laurens County
HORSE SHOW

Clinton, S. C.

August 30,
1940

8:00 P. M.

Johnson Field

Under the Lights

SPONSORED BY CLINTON LIONS CLUB

Horse show program.
Courtesy of Clinton Museum.

1944. In 1940, Dixie Beverages, which was later to become the Canada Dry Bottling Company, opened. In 1944, Columbus D. Childs opened Childs Funeral Home at 36 East Carolina Avenue. Later, he moved the business to 301 West Carolina Avenue, where it is still in operation under the leadership of his daughter, Ann Childs Floyd.

In 1936, Clinton lost its last Confederate veteran when James Watts Copeland died. He had been the owner of the J.W. Copeland Company, which was founded in 1892 and liquidated in 1920. Starting in the summer of 1936, Laurens County had a popular annual horse show, initated by George A. Copeland and often held at Johnson Field at Presbyterian College. Textile baseball continued to flourish. The Clinton Cavaliers won the championship of the Palmetto Textile League in 1938 with a record of 12-3. In July 1939, Clinton played Newberry in the first nighttime game in the Mid-Carolina League.

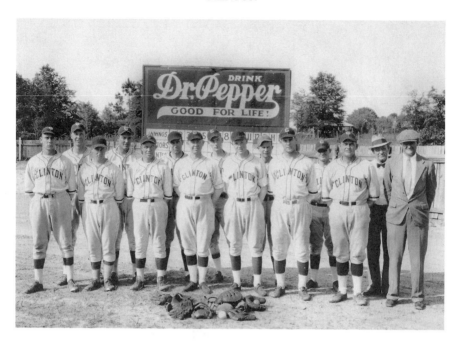

Clinton Mill baseball team, undated. *Courtesy of Clinton Museum.*

Mary Hardwick at a tennis exhibition, circa 1941. *Courtesy of Presbyterian College.*

When W.P. Jacobs II became president of Presbyterian College in 1935, one of his first ideas was to emphasize the tennis program. He brought clinics and exhibitions to Clinton that featured such internationally known players as Mary Hardwick, Alice Marble, Don Budge and Bobby Riggs. But the college was not the only place infected with tennis fever. The town itself held annual tournaments, featuring singles and doubles matches for both men and women. For several years, Virginia Sadler and Emily Dillard had a hard-fought singles rivalry. Men's participants included John Mimnaugh, Taylor Martin and Rufus Sadler. In May 1940, a Clinton High doubles team made up of Mimnaugh and Sadler won the state tennis title. High school football was also on a roll during this time under Coach R.P. Wilder, winning an upper state championship in 1938 and the state championship in 1939. Wilder later served for twenty-one years as the principal of Clinton High School and then for seven years as school superintendent.

WORLD WAR II

By 1940, the war in Europe had started, and although the United States had not yet joined the effort, men in Laurens County were required to register for the draft. There was also a national defense effort, and area Boy Scouts began to organize into civil defense units. There were three Scout troops in Clinton at this time: one sponsored by the Kiwanis Club, one by the Clinton Cotton Mill and one by the State Training School. The following year, the Boy Scouts conducted a successful campaign to collect aluminum in Clinton. The American Legion also contributed to the war effort by collecting waste paper for use in shell cases, blood plasma boxes, supply parachutes and cartons.

In December 1940, the local National Guard's Battery G was reorganized into Battery B of the 107th Coast Artillery, Anti-Aircraft. Guardsmen began preparing for a year's service in the U.S. Army. Before they departed for Camp Stewart outside Savannah, they were given a dinner by various civic groups in Clinton and a rousing send-off at the train station. That summer, the government once again instituted daylight savings time, the first time since 1919. In the midst of these preparations for war, there was also progress in town. In 1941, the Hallmark Shirt Company of New York opened a factory in the building formerly used

by the Stutz-Hadfield Silk Company. The plant employed one hundred people, 90 percent of them women.

When the United States entered the war in December 1941, the war effort intensified. Men were called to Camp Croft for draft physicals, and local members of the National Guard, who were already at Camp Stewart, began volunteering for overseas assignments. They were sent for further training in England and then deployed to North Africa. By February 1942, the first local sailor, Robert Wilton Martin, a former Thornwell student, had been killed in the Pacific. In June, Presbyterian College embarked on an accelerated course, a year-round program that would provide a four-year college education in three years. By the following February, PC was also operating a program to train cadets in aviation.

Clinton had its first blackout test in the summer of 1942, and rationing of such things as sugar, coffee, fuel oil, gasoline, tires and meat had begun. Clinton also lost a landmark when Thornwell's McCall High School, which had originally been built as Recitation Hall for Presbyterian College, burned down. In 1942, the new combined college/town library, funded by the WPA,

A flight line, Clinton, 1944. This image shows the aviation training school of Presbyterian College. *Left to right*: Giles (airport owner), Scroggins (instructor), T.V. Zulkowski, C. Lehayne, B.D. Woodham and H.H. Williams. *Courtesy of Brannan D. Woodham.*

opened. The building itself was owned by the City of Clinton but was located on land deeded to the city by the college. The books and equipment belonged to the college, and the college also supplied a librarian. The collections were open to all white citizens of Clinton and Laurens County without charge.

Textile league baseball continued to be a big attraction during the war. In 1942, the Clinton team captured the Mid-Carolina League championship. Two years later, the Brooklyn Dodgers signed Clinton's star pitcher, Claude Crocker. Crocker later returned to Clinton to coach and eventually worked as vice-president for human resources for Clinton Mills. Another star player at the time was Joe Landrum, who played for Clinton in 1945. He played for the Brooklyn Dodgers in 1950 and 1952. Teammate Ralph Rowe later became a hitting instructor for the Baltimore Orioles and the Atlanta Braves. The high school team was also doing well and won the Class B baseball championship in both 1944 and 1945.

August 1945 brought the long-awaited end to the war. The *Chronicle* described the lively scene in Clinton when the news broke:

> [A] *hilarious celebration instantly began and lasted for several hours. The fire siren and mill whistles gave the flash that the war was over. Crowds gathered on the public square filled with rapture that the four-year nightmare had come to an end. Whistles blew, lines of honking automobiles and trucks passed up and down the streets. The square was a bedlam with great crowds of men, women and children pushing up and down the sidewalks. The streets were littered with wastepaper and every possible sort of noise including bells, tin cans, horns, sirens and firecrackers, was heard in the city's greatest celebration.*

Stores, businesses and even the textile mills were closed, and residents attended a thanksgiving service at the Broad Street Methodist Church. All of the original men of Battery B returned from the war safely.

POSTWAR YEARS

Clinton, along with the rest of the country, experienced a postwar boom. In December 1945, Collie W. Anderson and H.L. Nettles filed to incorporate the Dapper Hosiery Mills. By 1951, this plant would employ 120 people and

A group of Clinton businessmen, 1940s. *Left to right*: Lee Willard, Mace Young, Frank Golden, Hubert Pitts, Mr. Swink and Lynn Cooper. *Courtesy of Clinton Museum.*

produce two million pairs of nylon hosiery a year. In December 1945, some of Clinton's citizens organized an Exchange Club under the leadership of Robert B. Hellams. By January 1946, the first new Packard automobiles were on display at Chandler and Cooper's on South Broad Street.

A walk around Clinton in 1945 would have revealed a number of businesses that were, or would become, fixtures in the lives of Clinton citizens. There were J.I. Copeland, Young's Pharmacy and Maxwell Brothers on North Broad Street, and East Main boasted Copeland and Stone and Hamilton's Jewelers. On West Main were the Keller Drug Store, J.C. Thomas Jeweler, the A&P supermarket and Giles Chevrolet. Musgrove Street featured the Sadler-Owens Pharmacy, George A. Copeland's hardware, Sumerel's, Prather-Simpson Furniture Store, Rose's, J.C. Penney, the Clinton Café and Adair's Men's Shop. L.B. Dillard's clothing store occupied a building at 119 South Broad, and the Country Market was on East Pitts Street.

In August 1946, the Seaboard Air Line, which had been in receivership for a number of years, returned to operation under private management.

Ken Horn of Presbyterian College wins first place in the shot put at the state track meet, 1952. *Courtesy of Presbyterian College.*

The Clinton Hotel, leased and operated by Mr. and Mrs. R.G. Murphy for the past eight years, was leased to the Howard Dayton hotel chain of Albany, Georgia. The following month, Buck Owens's three-ring circus and Wild West show presented two shows in town. L.W. "Andy" Anderson founded Anderson Flooring; his son, Robert, joined the company in 1950 and served as president until 1988. By 1947, PC had resumed its sponsorship of the state collegiate track meet, a fixture in Clinton since the 1920s.

The members of Providence ARP Church began to raise funds for a new building, and in 1952 they moved into their current brick building on the corner of South Broad and Walnut streets. In 1948, efforts resumed to establish an Episcopal church in Clinton. At first, services were held at Presbyterian College, but by 1950 the congregation had secured property on Calvert Avenue. The church was organized in January 1951, and by 1952 the Episcopalians had moved the old ARP church from North Broad Street to the corner of Calvert Avenue and South Holland Street.

Bank of Clinton. Photo by D.A. Yarborough. *Courtesy of Lawrence Young.*

In 1948, the Citizens Federal Savings and Loan Association moved into new fireproof offices at 220 West Main Street, along with Clinton Realty and Insurance. That same year, the Bank of Clinton, the first to offer Federal Deposit Insurance Corporation (FDIC) protection, opened on the corner of North Broad and Pitts streets. This bank, headed by R.P. Hamer, grew out of the Commercial Depository of Clinton organized in 1934. In the fall of 1948, the schools opened two weeks late because of the threat of polio. Although no cases were reported in Clinton, there were three in Laurens County. In November, Dr. George Blalock opened a clinic in the former J.A. Bailey home on North Broad Street. The clinic had a kitchen in the basement, waiting rooms, offices and operating rooms on the first floor and patient rooms on the second. It operated until Bailey Memorial Hospital opened in 1962.

In early April 1949, the new Broadway Theater opened under the management of J. Leland Young. The new cinema had seats for 600 downstairs and 244 upstairs and featured a crying room for mothers with small children. The schools were also undergoing major renovations, including the addition of a new auditorium at the high school. The Clinton

Florida Street School, circa 1946. *First row, left to right*: Peanut Smith, Toni Ray, Mary Keith Adair, Anne Baker, Edna Martin, Barbara Simmons, Elaine Addison and Charles Bonds. *Second row*: Emily Bailey, Sara Pitts, Susan Burns, Martha McMillan and Margaret Ann Bolick. *Third row*: Dawn Campbell, Mary Jean Lewis, Jerry Oates, Florence Winn, Sidney Bonds and Jim Gasque. *Fourth row*: George Blalock, Hub Adair, Mell Wilson, Bill Sease and Carroll Poole. *Fifth row*: Billy Pitts, Robert Horton, Alan Trammell, Earl Motes and Marion Ray. Photo by Modern Studio, Clinton. *Courtesy of Clinton Museum.*

district was being led by W.R. "Ned" Anderson, who served as superintendent from 1945 until 1964. Investors announced plans for a modern new hotel to be named the Mary Musgrove and located on land formerly belonging to Nina Vance Bailey on North Broad Street. In August 1949, Benjamin L. Thompson, the son of longtime Clinton drayman Herbert Thompson, opened Thompson's Mortuary. Thompson, a veteran of World War II, established the business on South Bell Street with his wife, Emma. In 1990, it was sold to Jesse Sanders.

In the fall of 1949, President Truman began to push for changes to the nation's civil rights laws. He proposed the Fair Employment Practices Act, part of a ten-point plan to ensure the civil rights of racial, religious and other minorities. The plan was also designed to end lynching and the poll tax. The fact that southern legislators would almost certainly filibuster the legislation, however, meant that it would be put off until the following year.

In February 1950, the Lydia Women's Club organized four groups of Camp Fire Girls in the Lydia community—the first such organizations in the Clinton area. By late 1952, a group had been organized in Clinton. The organization prospered, and by 1966 there were over five hundred members in Clinton and the mill communities. Camp Fire eventually ended in Clinton in 1993 after forty-five years.

By late 1950, local men were once again being drafted, this time for the Korean War. The following May, the new Mary Musgrove Hotel opened on North Broad Street. It featured carpeted rooms, private baths, a coffee shop and a large banquet room. Baseball continued to be popular in Clinton. In 1950, the Little League team won the state championship and traveled to the Little League World Series, where they lost to Bridgeport, Connecticut. According to the *Chronicle*, "Clinton's Little Leaguers fought against odds all the way in the tournament as they were the smallest boys in size to appear on the field of play. All of the boys showed up exceptionally well." In 1950, the Cavaliers

Mary Musgrove Hotel, North Broad Street. Photo by Nichols Photo Service, Clinton. *Courtesy of Lawrence Young.*

of Clinton Mills won the pennant in the Central Carolina Textile League. On May 9, over three thousand local fans watched the Cavaliers defeat Ware Shoals 6–5. The manager at the time was Claude Crocker, and one member of the team was Zeb Eaton, who had played for Detroit in 1944–45.

By 1950, Laurens County textile workers were receiving over $13 million in pay. Clinton Cotton Mills had over seventy-one thousand spindles and 1,800 looms. The mills at Lydia and Clinton embarked on an extensive modernization program. Upgrades at the Clinton plant included an office building, a new filter plant and a modern store, located at the corner of Bailey and Academy streets. In 1950, both Clinton and Lydia got fine new swimming pools. In 1951, the Bailey family organized the Bailey Foundation, which earmarked 5 percent of the mill's profits for charity. Since its organization, the foundation has contributed millions of dollars in support of almost every major project in Clinton. The following year, the *Clothmaker*, a monthly magazine that focused on mill news, debuted.

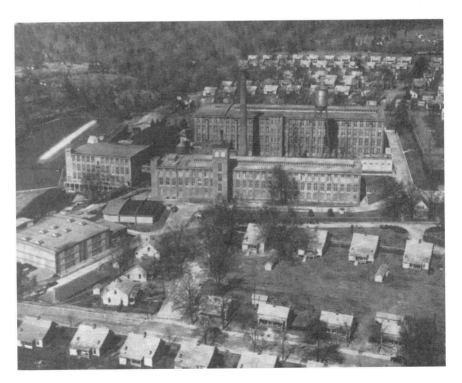

Clinton Cotton Mills. From the 1952 *Clintonian. Courtesy of Lawrence Young.*

Clinton Mills Store. From the 1954 *Clintonian. Courtesy of Presbyterian College.*

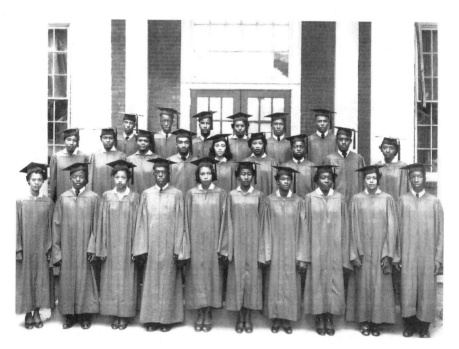

Bell Street School, class of 1949. *Courtesy of Clinton Museum.*

There were also other textile companies in town, including Gwen Evan Mills, Hallmark Manufacturing and C.W. Anderson Hosiery. Other major businesses included CWS Guano and Clinton Plywood Corporation. In 1951, Lawrence Warren opened the Clinton Paper Box Company on East Main Street. In 1952, citizens in Clinton and Newberry formed the Clinton-Newberry Natural Gas Authority. The authority was governed by the mayors of each city, two members from each city council and one member at large. The first offices were located in the old Clinton Hotel building, and the first manager was W.H. DuBose.

During the 1950s, inequities in the schools brought about big changes to both South Carolina and Laurens County. In 1950, a group of parents in Clarendon County asked a federal court to declare school desegregation unconstitutional. In June 1951, the Fourth District Court of Appeals declared that segregation was constitutional only if school facilities and curricula were equal. They also ruled that this was not the case in South Carolina. Governor Byrnes initiated a $75 million program aimed at making black schools equal to white schools, with funding to come from a 3 percent sales tax. The state also took over school transportation. Byrnes's program eventually provided $124 million for school improvement, including new construction and additional school buses. Although black students made up only 40 percent of the school population statewide, 66 percent of the new funding went to black schools. Schools were also consolidated, eliminating many of the one- and two-room rural schools in the state.

Chapter 4

INTO ITS SECOND CENTURY

A Brief Recap of Recent History

THE 1950S AND 1960S

For the first part of Clinton's second century, industry continued to grow. In 1954, the Textile Bobbin Works opened, followed by the Mobilmanor mobile home plant in 1958. In 1955, the Bailey Bank expanded and renovated its quarters on Pitts Street. In 1960, Grady Lee Stoddard Sr. founded Stoddard Plastering Company, a company that continues to provide stucco, lathing and plastering today. Four years later, Mr. Stoddard opened the West Side Motor Inn at 303 West Carolina Avenue, which he operated until his death in 1981. There were no hotel facilities in Clinton for blacks, and ironically, Mr. Stoddard had been traveling in the Southeast doing plastering work for various motel chains without ever being able to stay in them. Baseball great Willie Stargell actually stayed at the West Side Motor Inn.

In 1960, the Torrington Company started construction on the Clinton Bearings Plant, which went into full production in 1962. In 1964, the mills in Lydia and Clinton merged into one company, Clinton Mills, Inc. (CMI). By 1965, C.W. Anderson Hosiery had moved into the new industrial park on Highway 76 West. The following year, E.L. Mansure and Wometco Vending also opened plants in the park. Ascoe Felts, a division of Asten-Hill, built a facility in the park for the manufacture of wet felts for papermaking machinery. In 1966, CMI broke ground for the Bailey Plant, an $8 million mixed fiber plant to be located on the western edge of Clinton. This groundbreaking coincided with the seventieth anniversary of Clinton Mills.

Robert M. Vance, Emma Bailey Cornelson and George H. Cornelson at the open house for the new and expanded Bailey Bank, May 10, 1955. *Courtesy of Presbyterian College.*

J.W. Copeland Building, West Main and North Broad streets, 1957. *Courtesy of Lawrence Young.*

In 1959, 650 homes in the mill village were sold to textile workers at an average price of $3,500, and the city also had a new water and light plant. In 1961, Clinton had its first direct-dial telephone system, and by 1964 it was possible to dial even long-distance calls direct. The high school football team won the upper state championship in 1961 under Coach Claude Howe. The following year, Interstate 26 was opened, providing quick access to both Charleston and the North Carolina mountains.

The city also boasted new hospital facilities. The state legislature approved the Clinton Hospital District in 1959 and authorized its board to issue bonds. Additional funding came from federal Hill-Burton Funds, the Bailey Foundation and the Duke Endowment. Mrs. Elizabeth Young Dick donated part of the land for the new building. The fifty-two-bed facility, named Bailey Memorial Hospital in memory of Putsy Silas Bailey, opened on October 1, 1962. Bailey had served as president of the Clinton-Lydia Cotton Mills and was the mayor of Clinton from 1934 until 1946. A 1966 addition to the hospital provided fifty more beds, as well as improved laboratory, X-ray and pharmacy facilities.

Bailey Memorial Hospital. *Courtesy of Lawrence Young.*

P.S. Bailey. Photo by Nichols Studio, Clinton. *Courtesy of Presbyterian College.*

In 1965, the campus of Presbyterian College was enlarged by the addition of the East Plaza, which featured Richardson Science Hall, Greenville Dining Hall and Clinton Hall dormitory, home to the school's first resident coeds. During the late 1960s, many citizens became concerned about the loss of some of Clinton's most historic buildings—and with them some of its charm. In 1968, the old white frame CN&L depot was demolished, and it and the surrounding oaks were replaced by a parking lot. In 1968, Clinton lost all railroad passenger service.

There were substantial changes in the schools during the last half of the twentieth century. Bell Street School, which had added the twelfth grade during the 1948–49 year, burned down during the summer of 1949. Students attended classes in the Friendship AME Church and in temporary buildings until the school was rebuilt the following summer. This new building vastly improved high school education for blacks in Clinton. Other changes were needed in the district. The Academy Street School was over fifty years old

and was a fire hazard. The Hampton Avenue high school, built in 1919 and enlarged in 1928 and 1949, was located in a congested area of town. Basketball games were played at PC due to lack of facilities, and outdoor activities were conducted at the Florida Street School, which was located across a busy highway and a railroad track.

In June 1951, Laurens County schools were consolidated under a single board of education, headed by Charles F. Fleming. The state provided over $1 million to the district, including $93,000 for a new black elementary school in Clinton. In November 1952, however, Laurens County abandoned its single school district and was reorganized into two districts. Effective June 1953, Clinton would be located in District 56 with Joanna, Cross Hill, Jacks and Hunter townships and the Scuffletown area.

In May 1954, the U.S. Supreme Court ruled in *Brown v. Board of Education* (into which the Clarendon County suit had been bundled) that the concept of "separate but equal" schools was unconstitutional. South Carolinians were shocked by the decision, and white citizens' councils sprang up across the state to protest. Other groups, such as the interdenominational Christian Action Council and the South Carolina Council on Human Relations, joined the fight on behalf of civil rights.

In 1956, District 56 undertook an extensive building program. A new high school on North Adair Street replaced the old high school on Hampton Avenue, and the old high school became an elementary school. Grades eight

Bell Street School. *Courtesy of Presbyterian College.*

and up moved to a new "Bell Street" school on Lydia Mill Road, and the old Bell Street School was named Martha Dendy School in honor of principal David Dendy's mother. The district also built a new school, the M.S. Bailey Elementary School, on Elizabeth Street.

Society in Clinton at this time was still thoroughly segregated. There were separate waiting rooms at the doctors' offices and drugstores and separate hospital rooms for blacks. Drinking fountains and restrooms were separate, as were the waiting rooms at the train station and the cars on the train. Blacks sat in the balcony at the movies, and when the new Broadway Theater was opened, there was even a separate grand opening for African Americans. Black children were taught never to look a white person in the eye but rather to lower their heads when talking to them. Blacks had their own cafés, where they could sit down and order food. Other restaurants had separate walk-up windows at which they could order food to go, but they could not sit inside to eat. Some stores that sold merchandise to blacks would not allow them to try on clothes or shoes to be sure that they fit. Traveling was a problem; it was necessary to pack food to eat along the way and to either sleep in the car or keep on going at night because hotels that would accommodate blacks were scarce. Inequalities in education were very evident in Clinton. The black school got the old textbooks that had been discarded by the white school. When the new Bell Street School was built in 1956, it received used furniture, while the new Clinton High School received brand-new equipment.

The school situation was soon to change, however. By January 1966, District 56 had instituted a school choice plan, and forty-seven black students had enrolled in six previously all-white schools. Activities, programs, facilities and such services as transportation were to be provided to all students "without segregation or other discrimination because of race, color, or national origin." Teachers and staff were to be hired regardless of race. According to the *Clinton Chronicle*:

> *It will be something entirely new for this Southern, South Carolina city. It has been in the making for about 12 years—since the 1951 decision of the United States Supreme Court. It is something we did not ask for. It was forced upon us by an all-powerful government. Whether we like it or not—it is here. And it is up to us to determine its course—whether it will be for good or ill. Most of us, we suppose, will accept it with little evidence of emotion one way or the other—just tolerating it because we choose to abide*

122

by the law of the land. But knowing full well it were better for the majority of both races had it not been instituted. But we must place our full faith and substance on the line and demonstrate to our once more emancipated Negro brethren that they have our good will and our good wishes for their advancement and growth. Now, more than ever, it is the time for good sense, good reason and good will to dominate. We hope it shall ever be so.

It was not easy for some of the first black students enrolled in the white schools, however. One of the early students remembers being asked, "How much are they paying you to come to school here?" or "Why do you want to come to our school?" Some white students refused to pass close to black students in the hallways, making references to "N***** germs."

In March 1966, a few robed, but unmasked, members of the Ku Klux Klan visited Clinton. They were not welcomed in town, however. According to the *Chronicle*:

They walked around in a limited area of the business district and passed out some propaganda. We have heard no local persons say they recognized any of the Klansmen, so they must have come from another community. But their very presence here Saturday was obnoxious to most Clintonians. The organization serves no useful purpose and does not have the respect of any reputable segment of the community. White and Negro people know them for what they are. They can intimidate no one. Therefore, we feel that we speak for the people of Clinton when we tell them to go on their silly way and don't come back. That's about as plain as we can put it.

In 1968, Clinton had a new school, Clinton Elementary. That same year, the U.S. Supreme Court ruled that freedom-of-choice integration plans like Clinton's were unconstitutional, and Governor McNair formed the South Carolina Education Advisory Committee to facilitate the move to full integration. There was also agitation for integration at the college level, and students at PC began to question why there were no black students at the college. PC admitted its first African American student in 1969.

The move toward integration also resulted in African Americans being hired by Clinton's city government. Joe Moon was hired as Clinton's first black police officer in 1965. He resigned in 1967, but that same year, Willie James Carter and James "Jimmy" Jenkins were hired. Carter, who

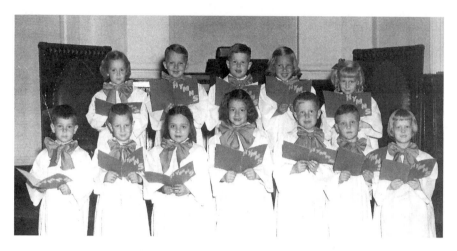

Kindergarten department, Broad Street Methodist Church, 1950. *Front row, left to right*: Howard Watkins, Mike Reddeck, Terry Copeland, Norma Davidson, Al Reid, Billy Trammell and Margie Arnold. *Back*: Dianne Pitts, Billy Ballard, William Milam, Connie Simmons and Roseanne McCrary. *Courtesy of Clinton Museum.*

served the city for fifteen years, was the first black officer to be promoted to sergeant.

Clinton had always been a churchgoing town, and there were ongoing changes in religious life. New churches included the Lydia Methodist Church (1954), the Assembly of God (1958) and the Davidson Street Baptist Church (1959). Davidson Street was originally organized as a mission church of Calvary Baptist and by 1960 had broken ground for a temporary sanctuary. In 1955, the First Baptist Church opened a new education annex, and the following year, both the Methodist and Presbyterian churches broke ground for similar additions. Hebron Baptist Church, under the leadership of Dr. W.D. Coker, opened its new sanctuary in 1958. Dr. Coker's wife, Mamie N. Coker, was also prominent in the community. She served as the principal of the Pleasant View Primary School and received the Order of the Palmetto in 1994.

In 1963, the Bailey Memorial Church also underwent a major renovation. A new Church of Christ was founded in 1964. The members met first at the home of Clarence Ham and then remodeled a frame building at 603 North Broad Street. They later replaced this with a brick building. Also in 1964, the last service was held in the old First Baptist Church; by 1966 the congregation was worshipping in an entirely new building. Meanwhile, in 1967, the members of Broad Street Methodist Church decided to demolish their building. By 1970, they had a new sanctuary.

The popularity of textile league baseball was waning, but in 1953 the Clinton team captured the Palmetto League championship with a record of 12-4. One of the stars of the 1950s was Kinard Littleton, who played high school, American Legion and textile baseball in Clinton and who later signed with the Cleveland Indians. In 1954, the high school baseball team won the state championship, and they were repeat champs in 1955, 1960 and 1961. Young people had a popular hangout—the Beacon Drive-In on the Whitmire Highway, which featured a dance floor. In 1957, the city's first radio station, WPCC, was chartered by a group of investors from North Carolina.

THE 1970s

By 1970, Clinton's schools were serving four thousand students with four elementary schools, two junior high schools and one high school. That year, after two years of "school choice," or partial integration, the public schools were fully integrated. During the summer of 1970, just prior to full integration, there was unrest in Clinton. In July, a group of young black men heard rumors that the Klan would be marching again and organized themselves to respond. When there was no march, most of them dispersed, but some participated in a number of fire bombings in and around Clinton. Local targets included the J.H. Pace Grocery at the intersection of highways 308 and 172, an empty building owned by Clinton Milling Company and Ben Bridgeman's Grocery Store and Pawn Shop at West Main and Bell streets. Total damage was estimated to be about $100,000. By September, twenty-six young black men, ranging in age from seventeen to twenty-five, had been arrested. Nineteen men were eventually prosecuted; they pled no contest and were sentenced to one or two years in prison and five years' probation.

After a restless summer, the schools opened peacefully. The *Chronicle* noted that

> *the opening of school this year has brought home the changes we've been reading about this summer...as we've said before, the keys are mutual respect, common courtesy and common sense...Your primary interest in the schools concerns the quality of education your child receives. The quality will be better if it is conducted in a relaxed atmosphere of cooperation.*

During the next few years, the district added vocational and classroom wings to the high school and made improvements to Martha Dendy and Bell Street schools. In 1970, the school at the Thornwell Home was opened to Clinton residents. It remained open as a private school until the spring of 2007, when Thornwell closed its entire school, and its resident students enrolled in the public schools for the first time.

There were continuing changes in the town. In 1970, the city hall moved to its new quarters on North Broad Street, and a forty-bed long-term care facility was added to Bailey Memorial Hospital. By 1974, there was another shopping center, Copeland Plaza, and the Belk store moved from downtown Clinton to new quarters there. In 1976, the Neely Medical Center opened near Bailey Hospital to provide office space to physicians. There was also growth in the churches. In December 1970, New Bethel AME Church held the first service in its new building. In 1971, Bailey Memorial Church underwent extensive remodeling, funded in large part by the Bailey Foundation. In 1977, Broad Street Methodist Church dedicated the Mullikin Family Activities Building, named for Reverend M. Eugene Mullikin.

In the late 1960s, the people of Clinton began to feel the need for a full-service public library separate from that of the college. The J.W. Leake family of Clinton gave land on North Broad Street, and additional funding was supplied by the City of Clinton, Laurens County and a federal grant. In June 1974, the new library building was opened.

In 1973, Clinton adopted the city manager form of government. The first city manager lasted only a few months. He was replaced by Leon Gilbert in 1973. Gilbert served the city until his retirement in 1982. In 1978, Clinton had its first black city council member, Lewis Knighton of Ward 1. He was to serve on the council for ten years. In 1974, Torrington underwent the last of six expansions. What had originally been a 135,000-square-foot facility had increased to 500,000 square feet, and the company was employing over 1,300 local people.

Clinton continued to lose some of its history and charm. In 1970, the large old maple trees in the median of Maple Street were removed and replaced with power poles. By 1976, the Academy Street School and the Phinney house on East Carolina Avenue, the oldest house in Clinton, had been demolished. In 1979, the old brick depot was torn down to improve traffic flow around the square.

In the face of all this change, Donny Wilder wrote a nostalgic editorial in the *Clinton Chronicle*:

> *I have a "sense of place" in Clinton, but much of it is in my mind. The place has changed and is changing…My "sense of place" (circa 1935–50) includes the Presbyterian College plaza where we played pick-up football games; the Clinton Mills swimming pool; some classrooms and hallways at Florida Street and Hampton Avenue schools; the National Guard Armory where our high school basketball team played its games and we danced "The Dip" to records at the "Teen Canteen"; the Florida Street School playground which was the practice field for the high school football team. In my old hometown, we were awakened by a mill whistle. In a red brick railroad station in the center of town, we "newspaper boys" rolled our newspapers before daybreak. The railroad station was an important place. There were many passenger trains bringing "strangers" into and through our town…Other special places for me were the livery stable on Hampton Avenue with the musty smell of hay and mules; the*

Frampton Hall, formerly the Mary Musgrove Hotel. *Courtesy of First Presbyterian Church.*

old Chronicle office on South Broad Street…where we bought our school supplies; the Clinton Mills ballpark where textile league games drew large crowds; the old Casino and Broadway theaters; the "dime stores"; the soda fountain at Sadler-Owens Pharmacy where we ordered wild concoctions of ice cream, chocolate syrup, nuts and fruits. Downtown stores attracted large crowds on Saturday…I remember Clinton as "tree shaded." Large, protective trees seemed to be everywhere, even downtown, making Clinton a very pretty place.

In 1975, the Synod of South Carolina opened the Presbyterian Home in Clinton, and the following year, the Mary Musgrove Hotel was converted into forty apartments for the elderly and renamed Frampton Hall. Things were changing greatly at Whitten Village during this period. By the fall of 1978, the state had diversified its work with the mentally disabled into four regional service areas, each with community services. As a result, the Department of Mental Retardation was moving hundreds of residential patients out of Whitten.

The Clinton Red Devils celebrate their state championship victory over James Island, 1977. From the 1978 *Clintonian. Courtesy of Presbyterian College.*

In 1977, the post office moved to new quarters on Elizabeth Street, and Collie Lehn led a group in buying the old post office building for a savings and loan. By October of the following year, plans were underway for a "ring road" to go from Highway 76E to Highway 72S. The Red Devils football team was enjoying a number of banner years under Coach Keith Richardson. Richardson's teams won the upper state championship in 1973 and 1974 and the 3A State Championship in 1972, 1977 and 1978.

THE LAST THIRTY YEARS

After decades of steady growth, Clinton's population actually decreased in 1980, down to 7,979. Unemployment was high, reaching 9 percent in Laurens County by 1981. There were, however, some new industries in town. Aaron Industries, a manufacturer of private label pharmaceutical products, opened in 1980. Dennison (now Avery-Dennison) opened a label manufacturing plant just outside of Clinton in 1982. Population figures had improved by 1990, when the census put Clinton's population at 9,603, including the residents of Whitten Center and the Presbyterian homes.

By the end of the twentieth century, however, Clinton's industrial base was beginning to shrink. In the spring of 1996, CMI closed its Lydia plant, resulting in the loss of four hundred jobs. In July 1997, CWS Guano closed after ninety-seven years in Clinton, and by August the familiar water tower had been demolished. In April 1999, the Bailey Financial Corporation, the oldest bank in Laurens County, merged with the Anchor Financial Corporation. This was followed less than a year later by the announcement that Carolina First Corporation had acquired Anchor Financial Corporation, which once again changed the ownership of the bank.

By the summer of 2001, the Vance Plant had closed, taking six hundred more jobs. That same year, the Bailey Plant closed. This was the end of a century-long way of life in Clinton, a demise mourned by Tommy Kitchens in the *Clinton Chronicle* on July 11:

> *The mill companies took great care of their people. They provided their employees with housing at a most reasonable rate, a school for their children, a store with the very best quality goods and a plant nurse who took care of the workers and their families. They also took exceptional*

care of the village itself. There was an outside work crew, just like the Clinton utility department, which kept the grass around the village cut, kept the street lights burning, and kept the storm drains open. They also sprayed the village for insect control during the summer. How many of you remember how the spray truck would come up and down the streets and back alleys with the brave children on bicycles chasing after the truck? The company also provided the villagers with a place to worship. There were churches for most of the denominations, and at one time there was also a graveyard provided. Many various activities were also provided for the villagers' children, and these included such things as cub scouts, boy scouts, girl scouts, small fry baseball, Pony League baseball and midget football. One of the most appreciated things provided to the children, and grownups, was the swimming pool during the summer. Any mama and daddy, looking for their son or daughter, need not look any farther than the pool...After knowing all the things which the mill companies provided to their workers, it would be hard for me to understand how anyone could say anything bad against them. To me, the only thing they could ever be accused of was caring for their workers.

Some of these job losses were recovered when Richloom Fabrics moved into the Bailey Plant in 2003, and Asten began an $18 million expansion in 1998. Other new jobs were created when Sterilite Corporation, a manufacturer of plastic products for the home, opened a plant on Charlotte's Road in 2004. More losses were to come, however, when Torrington, now owned by Timken, announced in 2005 that it would shut down its Laurens County operations. Anderson flooring subsequently moved into part of the empty Timken plant.

There were also some changes in city administration during this period. Leon Gilbert retired as city manager and was replaced by Russell Allen. Allen was replaced by Steve Harrell in December 1985. He served until 1995, when he was replaced by Charles Litchfield. Litchfield retired in 2001 and was replaced by C. Samuel Bennett. That same year, Troy Bentley retired after twenty-eight years with the fire department, almost twenty of them as chief. Allen Simmons retired from the police department after serving for thirty-two years, the last five as chief. He was replaced by twenty-one-year veteran Chesley Richards. Carroll Barker, who had been serving as assistant chief, replaced Richards in 1993. The following year, James Jenkins, who

was one of the city's first black police officers and had served for twenty-five years, retired. By that time, Truman Owens had been serving on the city council for twenty-five years; he did not retire until 2009.

Dianne Wyatt, hired in 1974, was the city's administrative assistant, a job she still holds today. In 1994, Clinton had its first female mayor when city council member Myra Nichols was elected to the post; she was reelected in 1998 and was succeeded by Randy Randall in 2003. Clinton's first black police lieutenant, Jake Simpson, retired in 1998 after twenty-five years of service. African Americans were becoming more prominent in city government. Stonewall Craig, the second black member of the city council, was elected in 1988 and served for eight years. Shirley Y. Jenkins was elected in 1994 and is still serving after sixteen years. Betty S. Kinard served on the council for eleven years, from 1996 to 2007.

In 1981, the city received a $500,000 Housing and Urban Development (HUD) grant to rehabilitate housing in the South Bell Street/Tribble Street neighborhood. An additional $300,000 was added two years later to complete the project. In 1982, the National Trust for Historic Preservation added the Thornwell–Presbyterian College Historic District to the National Register of Historic Places. In 1986, the city received yet another Community Development Block Grant, this time to renovate homes in the Livingston Street area. The outline of the city itself changed when the Lydia community was annexed into Clinton in 2001.

There was a radical change in healthcare services when, in 1981, the boards of the Laurens County Hospital and Bailey Memorial Hospital merged to form the Laurens County Hospital System. In early 1988, ground was broken for a new hospital between Clinton and Laurens, and the facility opened the following year. Clinton High's football teams continued to excel under Coach Keith Richardson, bringing home the upper state championship in 1982 and the 3A State Championship in 1985. They later won the upper state championship again under Andy B. Young in 1993. Young's teams won the upper state championship again in 2005 and the 3A State Championship in 2009.

Concern for the future of Clinton's historic downtown produced positive results in 1984 when the Clinton Uptown Development Association (CUDA) was organized. By December, CUDA had hired Robert Long as executive director, and by 1985 the organization had become part of the nationwide Main Street program. That same year, the National Trust for Historic

Preservation recognized the business district as a national historic district. CUDA proved to be a rather unstable organization, however, with continual questions about funding and a series of directors who stayed only a short time. By 2000, it had been replaced by the Clinton Economic Development Association. By 2003, Clinton had established a revived Main Street program under the direction of longtime city employee Dianne Wyatt.

There were changes in some longtime businesses in Clinton. The old Bank of Clinton building was demolished in 1985 as part of a wider downtown renovation. Dr. Jim Yarbrough and Dr. Gill Thomas opened their offices in Joe McDaniel's old Exxon Station on East Carolina Avenue in 1986. Dr. David Mixon, OD, moved his offices from North Broad Street to the old Western Auto building at 118 Musgrove. Hoyt Hanvey, a jeweler in town since 1973, moved into the old Parker Furniture Building at 126 Musgrove. Bob Cason, Lynn Cooper and George Layne bought the old Baldwin Ford dealership on North Broad from Tom, Harry and W.C. Baldwin, who were retiring. There were still some old perennials, though, including Adair's Men's Shop, Clinton Realty and Insurance and T.E. Jones and Sons furniture.

In 1986, a new armory was dedicated on Highway 72 North; by 1990, the old armory building on South Broad had been demolished. District 56 opened a new school, Eastside, in 1986 on land that was formerly the Whitten Center chicken farm. District 56 had its first African American school board member when Gloria Diane Anderson was elected in 1989; after serving for four years, she was elected to the Laurens County Council, on which she still serves today.

In 1986, John Woodside opened True Value Hardware store, and Leslie Anne Jackson and Jerri Lynne Lamb opened Tapestry. In 1987, the Broadway Theater on North Broad and the Hampton Avenue School were demolished, followed the next year by the old Clinton Hotel.

There were continuing changes in the churches. In 1981, First Baptist Church opened a new multipurpose building and built a bell tower to house the bell from the original frame church. In 1982, former members of the First Presbyterian Church organized Westminster Presbyterian Church, part of the Presbyterian Church in America. The congregation soon had facilities located on Route 56. In 1983, a new church, New Covenant Fellowship, was organized. In 1994, the members of Bailey Memorial Church, faced with an aging building and declining membership, built a new sanctuary on Springdale Drive. The first service at the new Springdale United Methodist

Church was held in June of that year. The following year, the Pentecostal Holiness Church demolished the old Bailey Church to make way for their new church building. In 1998, the First Presbyterian Church completed a major renovation, which included the dedication of a new Christian Life Center on South Owens Street. That same year, Broad Street Methodist Church dedicated a new family activities building.

In more recent years, there have been radical changes to the downtown. By 1999, there were plans to turn the Jacobs Press Building into apartments; this project was completed in 2001. The Clinton branch of the Laurens County Library was declared unsafe in 2001, and the library collection was moved into the former Eckerd's store on the Jacobs Highway. In 2002, the city celebrated its 150th birthday, and the Clinton Museum opened in the historic Griffin House on North Broad Street, which had been given to the city in 1997 by Jim Von Hollen. In 2002, the city began to plan for the Clinton Corporate Park, to be located on Highway 72 near I-26. It has since opened and is currently occupied by a Hampton Inn and Fatz Café. In October 2004, the depot stage, a replica of a small-town railway station, opened downtown. That same year, Carroll Barker retired after almost thirty-six years with the city, the last ten as police chief. The following year, the police and fire departments were combined into the Public Safety Department.

During this time, the city government was working hard at downtown revitalization. The South Carolina Department of Transportation gave Clinton a $200,000 grant in 2004 to beautify the historic district; this was followed in 2006 by a $900,000 rural infrastructure grant from the Department of Commerce. In 2007, the former Bailey Bank building became the M.S. Bailey Municipal Center and now houses not only the city offices but also the School District 56 offices. The residents of Frampton Hall were moved to the main campus of the Presbyterian Home, and the building is currently under renovation for the new Presbyterian College School of Pharmacy. A bond issue provided for extensive renovations to Clinton Elementary School as well as the construction of a new high school on the Ring Road.

Over its more than 150 years of history, the town of Clinton has had its ups and downs. Early progress was virtually stopped by the Civil War and Reconstruction. This was followed by the organization of the textile mills and the emergence of Clinton as an industrial town. The mills dominated economic life for a century, until they closed in the late 1990s. Over the

years, multitudes of people have worked long and hard to make Clinton an attractive and vital community. Citizens enjoy a rich cultural life, enlivened by the Laurens County Community Theatre, the Laurens County Chorale and numerous performances and nationally recognized speakers at Presbyterian College. Residents are also entertained by such citywide events as Town Rhythms and the annual Christmas parade. Despite the loss of industry and the decline in the vitality of Whitten Center and Thornwell Home the town has survived with a thriving college, new industries, vital churches and an attractive downtown.

Chapter 5

BRIEF INSTITUTIONAL HISTORIES

THORNWELL ORPHANAGE

In 1872, Reverend William Plumer Jacobs asked the session of the Clinton Presbyterian Church to establish an orphanage in Clinton. By 1873, the church had appointed a board of visitors and bought 125 acres of land from R.H. Williams. The board decided to name the orphanage "Thornwell Orphanage" in honor of noted Presbyterian theologian James Henley Thornwell. The first building, still standing, was named the Home of Peace. When it opened on October 1, 1875, it housed eight orphans, with Dr. Jacobs serving as president and his wife, Mary, as matron. Mary Dillard Jacobs died in 1879, but Dr. Jacobs served as head of the home until his death in 1917.

There were many changes during Dr. Jacobs's long tenure. From 1893 to 1903, the orphanage also offered a Mission Training School. By the time Dr. Jacobs died, there were fifteen cottages, seven school buildings, an infirmary, a dining hall and a museum at Thornwell, and the institution was serving two hundred children. In 1909, the faculty and students, who had been attending First Presbyterian Church, established their own church, Thornwell Memorial.

Dr. Jacobs was succeeded by Dr. L. Ross Lynn, who served until 1943. He brought the home through the rough times of the Great Depression. Due to the weak economy, Dr. Lynn was able to accomplish only a small amount of construction and renovation. During this time, however, he was able to get the high school fully accredited.

Dr. Malcolm A. Mcdonald succeeded Dr. Lynn and presided over a period of great growth, which lasted until 1971. Under his leadership, nine new cottages would be constructed, as well as a new grammar school/high school/auditorium complex. New farmland was cleared, and two new barns were built. During this period, Thornwell was serving as many as three hundred students at a time.

Changes were coming, however. The Civil Rights Act was passed in 1964, and there was increasing pressure from the church for its institutions to integrate. During Dr. McDonald's last year, the Thornwell school opened as a private school, accepting students from the local community. Because of its segregated policies, the Justice Department sued the school in 1970 for being in violation of the Civil Rights Act.

Dr. McDonald was followed by Robert J. Blumer, who served for seven years. Thornwell was beginning to serve fewer students, and the nature of the residents was changing. Many of them, rather than being orphans, were children from dysfunctional families.

John B. Pridgen replaced Blumer in 1978. Six years later, Thornwell accepted its first black students. The resident population was still declining. By 1981, there were only fifteen cottages open, and the home, with a capacity of 150, was serving only 111 students.

In 1986, Reverend Zane Moore took over leadership at Thornwell. Moore embarked on a major renovation program and raised a substantial endowment for the institution. He was replaced in 2000 by Robert W. "Skip" Stansell. During this period, the length of stay for each child was steadily decreasing, and there was a greater focus on reuniting children with their families. Currently, the home has thirteen cottages open, with six to eight students in each cottage. Cottages are now run under the "teaching family model." In 2007, the school at Thornwell closed, and residents, for the first time, began to attend Clinton public schools.

PRESBYTERIAN COLLEGE

Presbyterian College had its roots in the Clinton High School Association, which was founded in 1872. In 1880, the name of the society was changed to the Clinton College Association, and principal W.S. Lee was authorized to organize a freshman class. The first classes were held in the old academy

building in downtown Clinton, and the first class graduated in 1883. For many years, the college also offered primary and preparatory classes for younger students.

Shortly after the college was founded, M.S. Bailey and J.W. Copeland each gave $500 toward the construction of a college building, and the academy building was sold to the public schools. Additional contributions enabled the college to erect its first building, Recitation Hall, which stood on Broad Street on the present-day Thornwell campus. The college moved to the new location in 1886. In 1890, various presbyteries in South Carolina began to elect trustees for the college, and the name was changed from Clinton College to the Presbyterian College of South Carolina. Eventually, the primary and preparatory classes were eliminated.

In 1891, R.N.S. Young and J.W. Copeland donated sixteen acres on South Broad Street, on the site where the West Plaza sits today. The first building on the new campus, Alumni Hall dormitory, was completed in 1891. There was also a small wooden dining hall adjacent to the dormitory.

In 1904, the college was placed under complete control of the Synod of South Carolina. The synod decided to consider relocating the campus and accepted bids from other towns, including York, Chester, Bennettsville and Sumter. Clinton's citizens, however, worked hard to raise the money to keep "their" college, and it remained in Clinton. When W.J. Neville became president in 1905, he began to plan for the expansion of the campus.

When Dr. Neville died suddenly in 1907, he was replaced by Davison McDowell Douglas. In his fifteen years of leadership, Douglas revamped the curriculum, increased the number of sports teams, added ROTC and built four more buildings. When the Synod of Georgia joined in supporting the college in 1928, the name was shortened to "Presbyterian College."

John McSween replaced Dr. Douglas in 1928 and ably led the college through the early days of the Depression. When he returned to church ministry in 1935, he was succeeded by William Plumer Jacobs II, grandson of the founder, who proved an effective leader through the remainder of the Depression and World War II. He returned the college to solid financial footing and instituted such programs as the radio program and the popular tennis clinics. During the war, the college had an accelerated academic program, which produced college graduates and army officers in three years of continuous study. There was also an aviation training program on the campus.

In the latter half of the twentieth century, PC was blessed with dedicated, long-term leadership. Marshall W. Brown, who served for almost twenty years, added to the campus, increased the endowment and improved the academic program. Marc C. Weersing, who served for sixteen years, quadrupled the college's assets, built eight new buildings, improved the faculty and presided over both full coeducation and integration. It was during his administration that the college opened the new East Plaza.

Kenneth B. Orr replaced Dr. Weersing in 1979, serving until he retired in 1997. During Dr. Orr's tenure, the college's curriculum was expanded, the size of the faculty was increased by 25 percent, ten facilities were built and another four renovated and the endowment grew from $6 million to $52 million. Dr. Orr was replaced by John V. Griffith in 1998. During Griffith's eleven years at the helm, the college has completed a new strategic plan and undertaken a major fundraising campaign. Several buildings, including Lassiter Hall and a major addition to the Thomason Library, have been added to the campus. The college has opened a Confucius Institute, athletics are moving to Division I and a new school of pharmacy will open in 2010.

WHITTEN CENTER

In 1920, the State Training School for the Feeble Minded opened just outside of Clinton. The first head of the school was Dr. Benjamin Otis Whitten, a native of Pendleton and a graduate of Emory University. The facility originally opened with six male patients and a staff of four. Later, a small number of female patients were added.

Since state aid fluctuated, the early years were difficult, and Dr. Whitten had to spend much of his time raising funds. By 1930, however, the facility had a school and boasted an enrollment of 350 and a staff of 100. By 1957, the center bore Dr. Whitten's name and was serving nearly 2,000 residents. There were forty-six buildings and two hundred acres under cultivation. No longer under the supervision of the South Carolina Mental Health Commission, Whitten was governed by its own board of trustees. The board had just completed a huge building program, and there were plans for improvements in the school, hospital and dining facilities. The center included diary, poultry and hog farms. The plant was valued at $5 million, and there were 400 employees.

By 1965, when Dr. Whitten retired, Whitten Village boasted almost fifty buildings and was serving almost 2,500 people. The facility, however, was experiencing 20 percent overcrowding. Dr. Roy Suber replaced Dr. Whitten, and by 1970 there were 3,000 residents. Those in the Campus Area were trainable and attended a non-graded school and a vocational school. A full range of activities—including clubs, choir and recreation—were provided. The Circle Area included those who were not trainable, among them a number of nonambulant and semiambulant residents. New trends in social services were appearing, however, and because of improved community services, as many as 250 residents could be released each year. In 1978, for example, 281 residents were moved from Whitten to centers in the other three service regions in the state.

Dr. Suber was followed by Bill Doggett and, later, by Charles H. Chadwell. In 1979, the name of the facility was changed once again, from Whitten Village to Whitten Center. By 1984, there were similar facilities in other areas of the state, and the number of clients had decreased to 1,400.

APPENDIX

LIST OF MAYORS

This list is gleaned from Dr. Jacobs's diary, *Our Monthly* and other published lists of town officials. Under the early charters, what we would now call "mayors" were called "intendants." They were elected in January of each year. In 1891, the city moved to an October election, and intendants served for two years. This was also the first time that the intendant received a salary, set at no more than $100 per year. In 1906, the intendant's title was changed to mayor.

Year	Mayor
1862	Captain Jim Dean
1875	R.R. Blakely
1882	D.M. Little
1883	C.K. Hale
1884	R.R. Blakely/E.C. Briggs (Blakely resigned in July)
1885	W. Edgar Owens
1886–89	W.A. Shands
1890	W. Edgar Owens
1891–93	W.A. Shands
1893–95	W.J. Leake
1895–97	A.M. Copeland
1897–1908	W.A. Shands
1908–13	W.M. McMillian
1913–22	James R. Copeland
1922–24	W.H. Simpson

1924–26	J.F. Jacobs
1926–28	W.M. McMillian
1928	E.B. Sloan, who died only a few months into his term
1928–32	Jack H. Young
1932–34	H.Y. Abrams (died during term)
May–July 1934	F.M. Boland, mayor pro-tem
1934–46	P.S. Bailey
1946–50	Dr. L.E. Bishop
1950–54	Joe Terry
1954–56	Hugh L. Eichelberger
1956–60	Joe Terry
1961–66	J.J. Cornwall
1966–68	B. Noland Suddeth
1968–69	Harry C. Layton (died during term)
March–August 1970	B. Noland Suddeth
1970–72	J.C. Thomas
1972–74	J. Frost Walker
1974–76	Wyman Shealy
1976–78	William A. Weir
1978–81	Wyman Shealy (died in office)
1981–86	David Tribble
1986–94	Francis Blalock
1994–2003	Myra Nichols
2003–present	Randy Randall

BIBLIOGRAPHY

Clinton Chamber of Commerce. "Historical Facts, Clinton, S.C." Clinton, SC: Clinton Chamber of Commerce, circa 1970.

Clinton Chronicle, 1919–52, plus commemorative issues on November 12, 1970, and March 21, 1985.

Cooper, William C. "Clinton Library Society Was Organized in 1872." *Clinton Chronicle*, March 20, 1980.

Edgar, Walter. *South Carolina: A History*. Columbia: University of South Carolina Press, 1998.

Hammet, Ben Hay. "Whitten Village: Our Home for Slow-Learning Children." Undated manuscript but probably circa 1957. Can be found in the archives at Presbyterian College.

Jacobs, J.F., II. "Story of the Jacobs Religious List." N.p., circa 1962.

Jacobs, Thornwell. *The Life of William Plumer Jacobs*. New York: Fleming H. Revell, 1918.

Jacobs, Thornwell, ed. *Diary of William Plumer Jacobs*. Atlanta, GA: Oglethorpe University Press, 1937.

Jacobs, William P., III, ed. *The Scrapbook: A Compilation of Historical Facts about Places and Events of Laurens County, South Carolina*. N.p.: Laurens County Historical Society and Laurens County Arts Council, 1982.

Jacobs, William Plumer. "Personal Recollections of Clinton." *Our Monthly* (1916).

Lander, Ernest M., Jr. *A History of South Carolina, 1865–1960*. Chapel Hill: University of North Carolina Press, 1960.

Laurens County Schools. *Report of the Survey Committee*. N.p., 1952. Report can be found in the archives at Presbyterian College.

Leland, John A. *A Voice from South Carolina*. Charleston, SC: Walker, Evans & Cogswell, 1879.

Moore, John Hammond. *The Baileys of Clinton*. Clinton, SC: Bailey Foundation, 1998.

Our Monthly. Clinton, SC: Thornwell Orphanage Press, 1867–1917.

Owens, Sam. *Clinton*. Charleston, SC: Arcadia Press, 2000.

Perry, Thomas K. *Textile League Baseball: South Carolina's Mill Teams, 1880–1955*. Jefferson, NC: McFarland & Company, 1993.

Revels, Jennifer S. *Historical and Architectural Survey of Eastern Laurens County, South Carolina*. Final Report. N.p.: Palmetto Conservation Foundation, April 2, 2003.

Simpson, Joseph Horace. *Other Memoirs*. N.p.: privately published after 1967.

Sivewright, Alexander M. *God's People Serving God's Purpose: 125 Years of Ministry at Thornwell Home for Children 1875–2000*. Clinton, SC: Thornwell Home and School, 2000.

South Carolina Department of Archives and History. National Register Properties in South Carolina. Clinton Commercial Historic District, Laurens County (Clinton). www.nationalregister.sc.gov/laurens/ S10817730014.

Spencer, Dr. A.E. "Early History of Clinton." Undated manuscript of speech given to the Clinton Kiwanis Club sometime after 1930. Manuscript can be found in the archives at Presbyterian College.

Vance, Thomas A. "A Sketch of History: Clinton, South Carolina, 1970: An American Story." Typewritten manuscript, 2005. Manuscript can be found in the archives at Presbyterian College.

Wyatt, Dianne. Personal scrapbooks on events in Clinton.

Young, Lawrence. Personal scrapbooks on the history of Clinton.

INDEX

A

Aaron Industries 129
Abrams, H.Y. 142
Academy Street School 53, 71,
 120, 126
Actaeon Club 60
Adair
 Ed 35
 E.J. 61
 Ella 93
 I. Mack 95, 102
 James 10
 Joseph 10
 Mrs. C.B. 91
 Robert 59
Adair's Men's Shop 76, 108, 132
Allen, D.A. 49, 51
Allen, Russell 130
All Saints Episcopal Church 86,
 109
Alumni Hall 137
Anderson
 Collie W. 107
 Gloria Diane 132
 J.W. 80
 L.W. 109
 Robert 109
Anderson Flooring 109
Anvil Brand Shirts 91
A&P supermarket 108
Ascoe Felts 117
Assembly of God 124
Asten 130
Avalon Club 68
Avery-Dennison 129
Aycock, E.R. 53

B

Bailey
 C.M. 58, 93
 Eloise Davenport 60
 J.A. 61, 110
 M.S. 22, 25, 35, 36, 37, 39, 40, 41,
 44, 46, 48, 49, 51, 52, 57, 137
 Nina Vance 111
 P.S. 52, 119, 142
 R.L. 52
 William Cyrus 88
 W.J. 44, 52, 99
Bailey Foundation 113, 119, 126,
 144

Bailey Memorial Church 88, 124, 126, 132
Bailey Memorial Hospital 110, 119, 126
Bailey Plant 117, 129, 130
Bailey's Bank 44
Bailey's Woods 64
Baker, Mrs. 53
Baldwin
 Harry 132
 Tom 132
 W.C. 132
Baldwin Ford 102, 132
Bank of Clinton 110, 132
Barker, Carroll 130, 133
Barksdale, Carl 70
Barksdale, Mr. 22
Barre, Dr. 39
baseball 107, 125
 Little League 112
 textile league 64, 89, 94, 103, 107, 112, 125
Bass, Mr. 33
Beacon Drive-In 125
Bean, W.S. 54, 71
Beasley, Elbert 85
Bee-Hive Department Store 55
Belk Department Store 102, 126
Bell
 J.D. 62
 Mr. 22
 W.B. 33, 35, 37
Bell and Young 40
Bell Street School 83, 120, 122, 126
Ben Bridgeman's Grocery Store and Pawn Shop 125
Bennett, C. Samuel 130
Bentley, Troy 130
Bethel AME Church 43
Bishop, L.E. 142
Bishop, Mr. 40

Blakely
 Ewell T. 23
 Mattie 70
 R.R. 28, 33, 37, 141
 Tensie 70
Blalock
 Francis 142
 George 110
Blumer, Robert J. 136
Boland, F.M. 95, 142
Bond, Professor 37
Boozer, J.J. 37, 40, 49
Boum, E.H. 40
Bowen, W.B. 22
Boyd, B.H. 85
Boyd, Walsh 59
Boy Scouts 81, 90, 105
Branch, J.B. 68
Briggs and Sumerel 51
Briggs, E.C. 141
Broad Street Methodist Church 58, 73, 124, 126, 133
Broadway Theater 95, 110, 132
Brown and Smith 39
Brown, Marshall W. 138
Brown, Will 63
Bryan, W.J. 71
Burdette, Pierre 79
Burgess, Mrs. 22
Butler, A.J. 21
Butler, Mrs. 22

C

Calvary Baptist Church 59, 102, 124
Camp Fire Girls 112
Canada Dry Bottling Company 103
Carter, Willie James 123
Casey & Fant 90
Casino Theater 81
Cason, Bob 132

Cato's Market 94
Century Club 86
Chadwell, Charles H. 139
Chautauqua 81
Cherokees 9, 10
Childs, Columbus D. 103
Childs Funeral Home 103
Church of Christ 124
Citizens Building and Loan
 Association 68, 102
Citizens Federal Savings and Loan
 Association 102, 110
city hall 55, 90, 93, 126
city manager government 126, 130
Civic Improvement Association
 71, 86
Civilian Conservation Corps 101
Clary, James 40
Clinton Academy 33, 41
Clinton Agricultural Loan
 Association 85
Clinton Business League 65
Clinton Café 108
Clinton Carriage and Garage
 Works 72
Clinton Chronicle 57
Clinton Classical Institute 41
Clinton Clothing Company 58
Clinton College 41, 48, 136,
 137. See also Presbyterian
 College
Clinton Corporate Park 133
Clinton Cotton Mill 76, 85
Clinton Cotton Mill Library 71
Clinton Cotton Seed Oil Mill 54
Clinton Economic Development
 Association 132
Clinton Elementary School 123, 133
Clinton Enterprise 47
Clinton Fire Baptized Holiness
 Church 59. See also First
 Pentecostal Church

Clinton Friendship Association 99,
 100
Clinton Gazette 47, 51, 73
Clinton Ginnery 51
Clinton Hatchery and Feed
 Company 85
Clinton High School Association
 136
Clinton Hotel 109, 132
Clinton Milling Company 125
Clinton Mill No. 2 57, 62
Clinton Mills 113, 117
Clinton Mills, Inc. (CMI) 117, 129
Clinton Museum 133
Clinton-Newberry Natural Gas
 Authority 115
Clinton News 54
Clinton Paper Box Company 115
Clinton Plywood Corporation 115
Clinton Presbyterian Church 23,
 28, 33, 41, 135. See also
 First Presbyterian Church
Clinton Production Credit
 Association 95
Clinton Realty and Insurance 68,
 102, 110, 132
Clinton Uptown Development
 Association (CUDA) 131
Clinton Warehouse and Fertilizer
 Company 51
Clinton Warehouse Company 51
Clinton Women's Club 71
Clothmaker 113
Coggins, L.C. 79
Coker, Mamie N. 124
Coker, W.D. 124
College View 89
Commercial Bank 55, 71
Commercial Club 81
Commercial Depository of Clinton
 95, 110
Compton, D.T. 21, 22

Consolidated Telephone Company 53
Converse, T.E. 54
Cooper, Lynn 102, 132
Cooper Motor Company 102, 108
Copeland
 A.M. 37, 53, 141
 Duck 102
 Elbert 22
 E.T. 18, 33
 George 32
 George A. 103, 108
 George P. 18, 37
 G.L. 51
 Guy L. 94
 J.I. 51, 73, 102, 108
 J. Isaac 55
 J.R. 73, 76, 141
 J.W. 36, 37, 41, 48, 61, 64, 91, 103, 137
 J.W., Jr. 57
 Lee Lex 81
 R.E. 58
 W.D. 95
Copeland and Stone Company 47, 58, 108
Copeland & Bearden 22
Copeland Hotel 94
Copeland Plaza 126
Copeland's Café 94
Cornwall, J.J. 142
Country Market 108
Craig
 Dr. 32, 33
 J.S. 62
 J.T. 18, 28, 33
 Stonewall 131
 Thomas 18
Craig & Tobin 22
Crews, Joseph 22, 29, 31
Crews, T.B. 47
Crews, W.T. 73

Crocker, Claude 107, 113
Cromer, Foster 73
Cromer, Lindsay 73
C.W. Anderson Hosiery 115, 117
CWS Guano 115, 129

D

Dailey, L.P. 102
Dapper Hosiery Mills 107
Davidson, George 22, 32
Davidson, G.H. 14, 22, 33, 36, 42
Davidson, L.H. 47
Davidson Street Baptist Church 124
Davis, James W. 51
Dean, Jim 141
Dean, Tom 22
Dendy
 David 97, 122
 Martha 57, 97
 Norris 97, 98
 Robert 98
 Wade 47
 Young 57, 97
Dial, Drew 33
Dick, Elizabeth Young 119
Dillard, Emily 105
Dixie Beverages 103
Dixie Flour and Grain Company 72, 85
Doggett, Bill 139
Douglas, Davison McDowell 137
DuBose, W.H. 115
Duncan, John 10
Dunlap, Mrs. R.S. 20
Dunlap, Richard 22

E

Eastside School 132
Eaton, Zeb 113
Eichelberger, Hugh L. 142
Elbert Beasley's Pressing Club 85
Ellis, George 57

Ellis, George H. 64
Ellis Motor Company 81
E.L. Mansure 117
Eustace, Mrs. 22
Exchange Club 108

F

Fairborn. *See* Fairbourn
Fairbourn, Esther 22
Fairbourn, Mrs. 21
Farm and Garden 25
Fatz Café 133
Ferguson
 Charles M. 14
 E.W. 85
 Mad 22
 Miss 40
 R.E. 93
 Turner Brooks 57
Ferguson Ford 85
fire department 62, 64, 67, 68, 73, 76, 93
First Baptist Church 59, 68, 124, 132
First Methodist Church 18, 43
First National Bank 55, 62, 93
First Pentecostal Church 59
First Presbyterian Church 58, 61, 67, 68, 72, 88, 124, 132, 133, 135
Five Points 13, 14, 15
Fleming, Charles F. 121
Florida Street School 90
Floyd, Ann Childs 103
Floyd, L.W. 54
football 90, 105, 119, 129, 131
Forshe, Eugene 70
Foster, Joel 22
Frampton Hall 128, 133
Franklin
 Bob 21
 C.E. 25, 35, 44
 Charlie 32

Friendship AME Church 43, 44, 102
Friendship School 44, 83
Fritz, Mr. 33

G

Galloway, Albert 70
Galloway, Clarence E. 89
Garber, Murray 93
Garvin, Mr. 54
Gibbes, Daniel 24
Gilbert, Leon 126, 130
Giles, C.C. 93
Giles Chevrolet 93, 108
Gilliard Lingerie 91
Grange 33
Gray Funeral Home 102
Gray, Russell 51, 92, 102
Great Council of the Order of Red Men 86
Green, N.A. 33
Griffith, John V. 138
Guignard, S.R. 88
Gwen Evan Mills 115

H

Hale, C.K. 141
Hall, E.H. 71
Hallmark Manufacturing 115
Hallmark Shirt Company 91, 105
Ham, Clarence 124
Hamer, R.P. 110
Hamilton's Jewelers 108
Hampton Avenue School 73, 121, 132
Hampton Inn 133
Hampton, Mr. 40
Hampton, Mrs. 40
Hampton, Wade 37
Hanvey, Hoyt 55, 132
Harrell, Steve 130

Harris
 Cornelia 86
 Lon 22
 Mr. 22
 W.W. 57, 95, 98
Hatcher, Bernard N. 76
Hatton, Robert 57
Hawkins, Professor 40
Hays, Helen 76
Hays, Leslie St. Clair 75, 76
Hebron Baptist Church 43, 44, 89,
 124
Hellams, Robert B. 108
Henry
 B.H. 76
 H.D. 95
 William H. 22
Hicks, F.F. 76
Holland, Abraham 10
Holland, Jonathan G.A. 23
Holland's Store 14
Hollis, Jodie H. 90
Holmes, N.J. 33
Holmes, Zelotes 18, 33, 41
Home of Peace 73, 135
Hood, Nelson 22
hospitals 76, 91, 119, 131
Hot Hustler Racket Store 81
Howe, Claude 119
Huett
 Mr. 22
 Mrs. 22
 Richard 22
 Robert 22
Humphries, Mrs. M.G. 41
Hunter, Dave 55
Hunter, F.D. 54
Hunter, Theodore 20

I

Inabinet, T.A. 88
Industrial Supply Company 93

Inglesby 22
Irby, W.C. 33, 37, 40

J

Jackson, Leslie Anne 132
Jacobs
 J. Dillard 54
 J.F. 42, 54, 57, 64, 142
 Mary Dillard 135
 Thornwell 52
 William P., II 89, 105, 137
 William Plumer 14, 20, 52, 57,
 68, 72, 77, 135
Jacobs & Company 54, 55, 71, 85
Jacobs Press Building 133
James, A.D. 40
J.C. Penney 61, 108
J.C. Thomas Jeweler 108
Jeans, P.S. 81
Jenkins, James 123, 130
Jenkins, Shirley Y. 131
J.H. Pace Grocery 125
Johnson
 Davie 18
 Mr. 22
 R.W. 76
 Walter 95
 W.D. 22
Jones, Amelia 40
Jones, B.S. 21
Jones, Professor 41

K

Kahn and Isemann 39
Keller Drug Store 108
Kinard, Betty S. 131
Kiwanis Club 85
Knights of Pythias 86
Ku Klux Klan 25, 123, 125

L

Lamb, Jerri Lynne 132
Landrum, Joe 107
Langston, Mrs. 22
Lankford, Oliver 79
Laurens County Hospital System 131
Laurens County News 54
Layne, George 132
Layton, Harry C. 142
L.B. Dillard's clothing store 108
Leake, Captain 22
Leake, Gideon 57
Leake, J.W. 33, 126
Leake, W.J. 51, 141
Leaman, Hugh 70
Lee, Allie 57
Lee, Arthur 57
Lee, William States 33, 136
Lee, W.S. 41
Lehn, Collie 129
Leland, John A. 32
Lewis, Knighton 126
Lewis, Reverend 54
Library Society 33, 35, 39, 44
Lilliewood, E.L. 57
Lilliewood's Grocery 72
Lions Club 95
Litchfield, Charles 130
Little
 C.C. 57
 D.M. 141
 J.H. 51
 Jonathan 22
 J.P. 52
 Thomas 15
Littleton, Kinard 125
Lollis, Marvin 97
Long, Edward 95
Long, Robert 10, 131
Lydia Baptist Church 59, 88
Lydia Cotton Mill 58, 85
Lydia Methodist Church 124
lynchings 55, 96, 97
Lynn, L. Ross 135

M

Mark, A. 33
Martha Dendy School 97, 122, 126
Martin
 A.V. 68
 Henry M. 25
 H.M. 21
 Robert Wilton 106
Mary Musgrove Hotel 111, 112, 128
Masonic Temple 55, 81
Maxwell Brothers 108
McCall High School 106
McCaskill, K. 53
McCaslan, Eliza 53
McCrary and Ferguson 44
McCrary, G.B. 33, 37, 39, 42
McDowell, George W. 23
McFadden, M.J. 76
McGhee, S.H. 62
McKelvey, James 15
McKelvey, John 15
McKelvey, Mary 15
McLees, Robert C. 70
McMillian
 Billy 102
 Joe 57
 Lonnie 90
 W.M. 141, 142
McSween, John 137
Mensing, H.C. 39
Milam, J.F. 72
Miller's Music Store 94
Milling Grocery Company 72
Milnor, William 42
Mimnaugh, John 105

Mixon, David 132
Mobilmanor 117
Moon, Joe 123
Moore, Zane 136
Morgan, Reverend 40
Mount Moriah Missionary Baptist
 Church 18, 59, 88
movies 72
M.S. Bailey Elementary School
 122
M.S. Bailey Municipal Center 133
Mullikin, M. Eugene 126
Murphy, R.G. 109
Musgrove County 72
Musgrove Volunteers 33

N

National Guard 95, 105, 106
National Guard Armory 102, 132
Neely Medical Center 126
Nettles, H.L. 107
Neville, Julia 71
Neville, W.J. 137
New Bethel AME Church 43, 88,
 126
New Covenant Fellowship 132
Nichols, Myra 131, 142
Ninety Six District 12

O

O'Daniel, A. 57
Order of Good Samaritans 85
Orr, Kenneth B. 138
Our Monthly 25, 33, 144
Owens
 Robert 21
 Robert L. 15
 Robert S. 18, 23, 57
 Truman 131
 W.B. 49, 52
 W.E. 52

 W. Edgar 141
 William 76

P

Parrott
 James 54
 J.B. 41, 47
 Reverend 62
 S.F. 54
Passly, Dr. 21
Peake, Mrs. 51
Peake, T.J. 76
Pentecostal Holiness Church 86,
 88, 133
Perrin, Wade 31
Phinney and West 22
Phinney, Robert 14, 22
Phinney, Robert S. 18, 22
Phinney, R.S. 37
photographers 18, 28, 35, 39, 42
Pitts, Mrs. Henderson 86
post office 14, 21, 25, 73, 85, 129
Prather-Simpson Furniture 108
Presbyterian College 41, 62, 90,
 103, 106, 120, 123, 136, 137
Presbyterian College School of
 Pharmacy 133
Presbyterian Home 128
Price, Mrs. 41
Pridgen, John B. 136
Providence Associate Reformed
 Presbyterian Church 58, 86,
 109
public library 71, 73, 89, 106, 126,
 133

R

railroads 15, 21, 28, 39, 44, 48, 49,
 83, 108, 120
Randall, Randy 131, 142
Rantin, H.D. 57

Recitation Hall 42, 106, 137
Red Shirt Club 37
Religious Press Advertising
 Syndicate 54
Richards, Chesley 130
Richardson, Keith 129, 131
Richloom Fabrics 130
Riddle, Johnny 89
Robertson, Mr. 51
Robinson, Mrs. S.Y. 33
Rose, Mr. 33
Rose's 108
Rose, William 22
Rotary Club 86
Rowe, Ralph 107
Russel, R. 25

S

Sadler-Owens Pharmacy 108
Sadler, Rufus 105
Sadler, Rufus E. 76
Sadler, Virginia 105
schools 18, 25, 33, 40, 41, 44, 53,
 71, 73, 83, 94, 110, 115, 120,
 121, 122, 125, 126, 136
Second Baptist Church 59
Second Presbyterian Church 52
Shands, W.A. 22, 51, 59, 64, 141
Shealy, F.K. 76
Shealy, Mr. 95
Shealy, O.I. 95
Shealy, Wyman 142
Simmons, Allen 130
Simms, Mary Lyles 41
Simpson
 George 22
 Hugh 70
 Jake 131
 Joe 52, 57, 64, 73
 Jonathan W. 15
 Stobo J. 33
 W.H. 141

Sims, A.A. 89
Sims, E.O. 51
Sims, Mamie 53
Sloan, Blakely 51
Sloan, E.B. 142
Sloan, E. Blakely 70
Sloan's Chapel 24, 40, 73
Sloan, Squire 22
Smith. D.B. 102
Smith, G.W.B. 76
Smith, Mr. 50
Southern Bell 54, 92
Southern Presbyterian 54
Spencer, A.E. 54, 64
Spencer, Annie 41, 53
Spencer, Martha Calvert 64
Spratt, John 70, 85
Spratt, Tom 70
Springdale United Methodist
 Church 133
Stansell, Robert W. 136
state track meet 90, 109
State Training School 81, 83, 138
Steinberg, S. 40
Sterilite Corporation 130
Stevens, John 102
St. John's Evangelical Lutheran
 Church 86, 88
Stoddard, Grady Lee 117
Stoddard Plastering Company 117
Stone, Chaney 102
Stone, C.W. 58, 85, 95
strikes 93, 99
Stutz-Hadfield Silk Corporation
 91
Suber, Pratt 33
Suber, Roy 139
Suddeth, B. Noland 142
Sumerel and Briggs 47
Sumerel, B.F. 93
Sumerel's 51, 108
Sumerel, T.C. 40

Sumerel, Thad 51
Sumerel, Will 51

T

Tapestry 132
Teague, W.S. 28
T.E. Jones and Sons 132
temperance 36
tennis 105
Terry, Joe 142
Textile Bobbin Works 117
Thomas, Gill 132
Thomas, J.C. 142
Thompson, Benjamin L. 111
Thompson, Herbert 74, 111
Thompson's Mortuary 111
Thornwell, James Henley 135
Thornwell Memorial Church 68, 72
Thornwell Messenger 68
Thornwell Orphanage 28, 35, 36, 39, 42, 61, 67, 68, 126, 135, 144
Tibbetts, Collette 86
Todd, C.M. 54
Todd, F.M. 54
Todd, H.L. 54
Todd, J. Hubert 93
Torrington Company 117, 126
Tribble, David 142
Tribble, D.E. 51, 73, 92, 102
Tribble, Mr. 71
True Value Hardware 132
True Witness 25
Turner, Neil 70

U

Union Station 65, 67
United Textile Workers 99
Utopia Building 55

V

Vance, Mary Bailey 60

W

Wade, R.W. 95
Wadsworth, Clint 57
Wadsworth, Milliken 57
Walker. J. Frost 142
Wallace, Drucilla 57
Warren, Lawrence 115
Watts, W.D. 37
Watts, William Dendy 15
Wax, Manuel 51
Wednesday Music Club 86
Weersing, Marc C. 138
Weir, William A. 142
Westminster Presbyterian Church 132
Westmoreland, Thomas 10
West, S.L. 25
Whitten, B.O. 81, 138
Whitten Center 128, 138, 139. See also State Training School
Wilder, R.P. 105
Williams, Bob 21, 32
Williams, J.Y.H. 25
Williams, L.G. 15
Williams, R.H. 35, 135
Wilson, Charlie 89
Winn, Sallie 41
Witherspoon, J. Harvey 94
Wofford, H.C. 37, 39, 51
Wofford, Mr. 46
Women's Music Club 86
Wometco Vending 117
Woodside, John 132
Woods of College View 89
Workman, Mrs. Hugh 57
Workman, Reeder 102
WPCC radio 125
Wright and Fergusons 39

Wright Building 71
Wright, George M. 81
Wright, James M. 18
Wright, R.Z. 37, 52, 62
Wyatt, Dianne 131, 132

Y

Yarborough, Jim 132
Young
 Agnes 10
 Andy B. 131
 Elihu 32
 George W. 57, 89
 Henry Clinton 15
 Jack H. 142
 Jack Holland 47, 95
 James Lee 51
 J. Leland 110
 John 51
 John H. 95, 102
 John T. 89, 95
 John W. 40, 47, 51
 Mr. 22, 36
 R.N.S. 14, 15, 21, 28, 37, 40, 48,
 137
 W.H. 51
Young's Pharmacy 47, 73, 108

ABOUT THE AUTHOR

Nancy Griffith, a native of Pittsburgh, Pennsylvania, is a graduate of Dickinson College and Syracuse University. She has worked as a librarian for the past twenty-five years and developed an interest in local history while serving as director of the Regional Studies Center at Lyon College in Batesville, Arkansas. While in Arkansas, she was on the board of the Independence County Historical Society and published numerous articles on county history. For the past ten years, she has been the head of Archives and Special Collections at Presbyterian College in Clinton, South Carolina. Since moving to Clinton, she has published a photographic history of Presbyterian College and a history of the First Presbyterian Church.

Visit us at
www.historypress.net